IMAGES
of America

FRANCO-AMERICANS
IN THE
CHAMPLAIN VALLEY

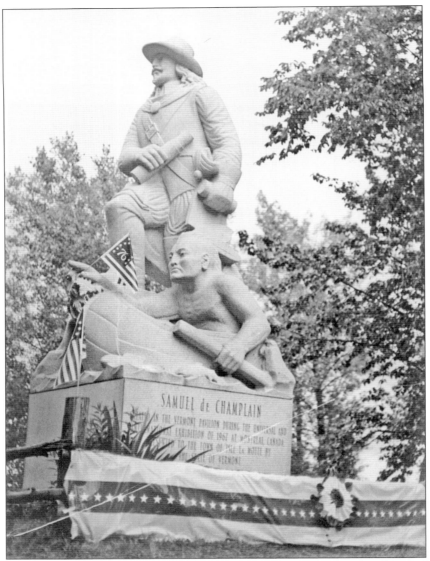

A monument to Samuel de Champlain on Isle La Motte, Vermont, was sculpted at the Vermont pavilion during Expo '67 in Montréal, Québec, and then transported to the island. It is believed to have been placed on the spot where Champlain stopped on his exploration of the lake in 1609. (Courtesy St. Michael's College.)

ON THE COVER: This panoramic photograph of the Convention of the Union Saint-Jean-Baptiste was taken on June 16, 1928, by Louis McAllister in Burlington, Vermont. As early as 1869, French Canadian revelers filled the streets to celebrate Saint-Jean-Baptiste Day. Events usually included a parade, the end of which would often be a young boy representing Saint Jean-Baptiste along with a live lamb. The holiday observance was brought to New France by the French as early as 1638. Lively celebrations were common in Québec until the 1960s. Some areas still celebrate the day but with much less enthusiasm than their ancestors had. Celebrations of the day in New York and Vermont are almost nonexistent today. (Courtesy University of Vermont Special Collections.)

IMAGES
of America

FRANCO-AMERICANS IN THE CHAMPLAIN VALLEY

Kimberly Lamay Licursi and
Celine Racine Paquette
Foreword by James D. Brangan

ARCADIA
PUBLISHING

Copyright © 2018 by Kimberly Lamay Licursi and Celine Racine Paquette
ISBN 978-1-4671-2786-8

Published by Arcadia Publishing
Charleston, South Carolina

Printed in the United States of America

Library of Congress Control Number: 2017951930

For all general information, please contact Arcadia Publishing:
Telephone 843-853-2070
Fax 843-853-0044
E-mail sales@arcadiapublishing.com
For customer service and orders:
Toll-Free 1-888-313-2665

Visit us on the Internet at www.arcadiapublishing.com

CONTENTS

Foreword 6

Acknowledgments 7

Introduction 8

1. Leaders and Citizens 13

2. Religion 41

3. Work 59

4. Winooski 83

5. Culture 101

Foreword

The news today is filled with stories of immigrants, refugees, and migrant workers coming to the United States. Some are welcomed. Some are tolerated. Some are met with disdain. The vitriol, distrust, and racism the latter groups encounter are nothing new. Today, pundits complain about immigrants stealing American jobs. They voice concerns about their religion. They publicly warn against the violence these people will inflict.

This is nothing new. The Constitution was less than a decade old when the Alien and Sedition Acts were passed to make it difficult for immigrants to become citizens and to imprison or deport immigrants declared dangerous or from hostile countries. The American nativist animosity toward the wave of Roman Catholic Irish fleeing famine led to the creation of the anti-Catholic American Party. Known as the "Know Nothings," the American Party wielded significant political power in the 1850s, including electing 52 members to the House of Representatives in 1854.

It wasn't just European immigrants that were treated unfairly by nativist Americans and their government. The Chinese Exclusion Act of 1882 banned all immigration from China. Described as "nothing less than the legalization of racial discrimination," the act was repealed in 1943. The 20th century ushered in a new wave of mostly Catholic immigrants from southern Europe and Québec. In response, the nativist movement revived in the form of the Ku Klux Klan, which was anti-immigrant and anti-Catholic.

While French-speaking people from Québec had been crossing the US border since our country was founded, the open contempt of the early 1900s must have been harrowing to the Québécois farmers searching for better agricultural fields, laborers looking for jobs in the mills, or lumberjacks hoping for work in the Adirondacks. Ironically, these new arrivals were not welcome in the Irish American churches. Nativists demanded that they speak English. This led French Canadian Americans to build their own churches, establish social clubs, and live in segregated communities.

America is a melting pot. Within a few generations, names like Dubois, Tremblay, and Béchard are commonplace. They're the names of businesses, farms, and our neighbors. Unfortunately, with this assimilation comes the loss of some French Canadian traditions: the St. Jean Baptiste Day celebrations and parades, the family kitchen party, and, sadly, French-speaking households.

This book is not just a celebration of French Canadians; it's a celebration of immigration. The United States is a nation built by immigrants, refugees, and migrant workers. That is something we all need to remember, regardless if your name is Jones, Mubark, Schmidt, Lapierre, Nguyên, Rossi, Huang, or Brangan.

—James D. Brangan
Assistant Director
Champlain Valley National Heritage Partnership

Acknowledgments

This book could not have been finished without the help of Champlain Valley residents and organizations who graciously shared their time and knowledge. We wish to give special thanks to the Champlain Valley National Heritage Partnership and assistant director James Brangan; John Fisher of the Vermont French-Canadian Genealogical Society; and Rita Martel and Joseph Perron of the Winooski Historical Society. Additionally, we are grateful for the support provided by Helen Nerska and Geri Favreau at the Clinton County Historical Association; Elizabeth Scott, archivist at St. Michael's College; Kathleen Messier, archivist at the Diocese of Burlington; Debra Kimok at SUNY Plattsburgh Special Collections; Gloria McEwen at the Isle La Motte Historical Society; Elizabeth Maisey at Assumption College; Jan Couture, Redford historian; Sylvia Parrotte at Plattsburgh City Hall; Polly Paré at the Swanton Historical Society; Louise Haynes at the Saint Albans Museum; Betty Brelia at the Anderson Falls Historical Society; Christopher Burns at the University of Vermont; Jim Davidson at the Rutland Historical Society; Bob Bayle at the Chapman Museum; Dr. Anastasia Pratt, Clinton County historian; Msgr. Dennis Duprey at St. Peter's Church; Bixby Library in Vergennes; Waterford Museum; Library of Congress; Ceal Moran; Christopher B. deGrandpré; Ernest Pomerleau; Robert Picher Sr.; Elizabeth Ménard; Gabriel Gagné; Ginette Warner; Christine Racine; Jane Béchard West; Barbara Racine; Randy Willette; Deane Tremblay; John Anctil; June Béchard Trombly; Janet Carey; William DuBois; Annette Picher; Louise Rocheleau; Clifton Gamache; Lynn Kelley; Tom Hughes; John Krueger; Kurt Kaufman; Mary Jo Maher; Gloria Ashline; John Zurlo; Robert Cheeseman, Chazy historian; Samuel de Champlain History Museum; and Sylvia Newman.

INTRODUCTION

The French influence in northern America has its genesis in Samuel de Champlain's travels on Lake Champlain and in the St. Lawrence River valley during the age of exploration in the early 17th century. His first trip was in 1603 following the path originally charted by another French explorer, Jacques Cartier, who was the first European known to explore the Gulf of St. Lawrence, in 1535. Champlain was sent by King Henry IV of France to map out New France and further establish French dominance in the region. He stayed for three years, mainly recording geographical features and planning for settlement in the area. On his second trip to North America in 1608, he founded Québec City. By the time of Champlain's death in 1635, there were 150 people living there. It was the second permanent settlement the French made in Canada after Port Royal, and it continued to grow as the lucrative fur trade expanded. Champlain gathered numerous fur traders into one organization, the Company of One Hundred Associates. A permanent trading post was subsequently established in Québec City.

Land in New France was divided among landlords through a manorial system. The French had claimed all the land from Montréal to Florida and as far west as Louisiana as part of New France and needed to settle the land to maintain control. This became a chief concern. The seigneuries, or manorial allotments, were plotted on the map in Québec and on both sides of Lake Champlain in what is now New York and Vermont. The seigneurial system was essentially a semifeudal one with landlords and tenants. The seigneurs were granted the land by the king, but they needed to clear it to keep title to it. Because the land grants were often quite large, they secured subtenants, usually tenant farmers, or habitants, who would pay rent for the property in money or labor.

Populating New France was more difficult than anticipated. For a decade, beginning in 1663, the French government sent 800 women to the colonies to further entrench French control by increasing the population. Les Filles du Roi (the King's Daughters), as they were known, were single women between the ages of 15 and 30 who were given dowries and free passage to the New World so that they might marry colonists and raise families in New France. The plan was a success, and the population doubled in 10 years. Marriages between colonists and natives were encouraged as well and were relatively common in the early years of settlement between French men and aboriginal women. The offspring of these intermarriages are known as Métis, which comes from the French *métisser*, meaning "to crossbreed." Most people with French Canadian ancestry in northern New York and Vermont can either trace their lineage back to one of these *filles du roi* or have a Native American in their family tree.

As the population grew, settlement spread farther afield, and conflict with natives became more common. Samuel de Champlain had forged an alliance with the Hurons, Montagnais, and Algonquins against their common enemy, the Iroquois. This would have dire effects during the Seven Years' War (also known as la guerre de la Conquête), when the Iroquois joined forces with the British. The British were victorious and took control of all the lands that had constituted New France. Many disputes arose between the French seigneuries and government officials.

Just 12 years after the end of the Seven Years' War, the American Revolution began. The British, the old adversary of the French, were not favored by French Canadians in North America, and many joined the Continental Army to fight against their old enemy. A Canadian regiment under the command of the American Moses Hazen was recruited in Québec, Nova Scotia, and the United States. Hazen's regiment, the 2nd Canadian, fought in several battles, including the culmination of the war at Yorktown in Virginia. France is also tied to the Revolution because as a nation it sided with the American rebels over the English Crown. The Marquis de Lafayette was a key figure who convinced the French government to provide troops and financial support to the Continental Army. Lafayette also fought alongside Gen. George Washington.

At the close of the war, Hazen's Canadian soldiers and their families became refugees. Hazen petitioned Congress to provide land grants as a bounty for service, but legislators were not quick to provide compensation to the French. American Continental soldiers had been promised land grants at the close of the war and received them after the victory at Yorktown. Hazen pressed on until the State of New York agreed to provide land grants for his compatriots in the northernmost regions of eastern New York. Many of the French Canadian veterans awarded land ultimately sold it to speculators and moved back to Canada. A few hearty souls stayed and struggled to survive as farmers in what was then a sparsely populated area on the outer fringes of civilization. Along with the early seigneuries along Lake Champlain, the new settlements of French Canadians in what was called "the refugee tract" lent a distinctly French flavor to northern New York towns.

Some of the original French settlers in New York are explored in the first chapter of this book, and they include Jean Laframboise, Prisque Asselin, and Antoine Paulint. One of the earliest notable settlers in Vermont was Captain Mallett, a Frenchman about whom very little is known. Mallett's Bay in Colchester, Vermont, is named in his honor. Captain Mallett was a reputed pirate with a checkered history. His activities, the source of his wealth, and why he chose to settle in Vermont in the mid-18th century are a mystery.

More French settlers were inspired to move south of the border after the Papineau Rebellion from 1837 to 1838. Louis-Joseph Papineau led a movement of Francophones in Lower Canada against the discriminatory governing and social practices of the English majority. Papineau and his supporters, called "Patriotes," believed that the Crown gave disproportionate power and influence to those of Anglo background, marginalizing the French. The early 1830s was also a period of declining economic conditions, which made for a discontented population. The rebellion was not successful, and the French effectively remained under British control. Poor economic prospects, combined with concern about disrespect for the French, encouraged immigration to New York and Vermont. One such émigré, Ludger Duvernay, started publication of *Le Patriote Canadien* in Burlington, Vermont, in 1839. Duvernay was the first Canadian immigrant to launch a French-language newspaper in the United States. It would be followed by many more.

Shortly after the Papineau Rebellion, the Civil War drew additional French to a fractured America. French Canadians came to fight for various reasons, including large cash bounties for service, a thirst for adventure, and compassion for the cause. Many who fought would ultimately make their homes in the United States, often close to the border in New York and Vermont where they had enlisted. The Civil War drove tremendous industrial growth in the United States and gave rise to a new manufacturing economy. Textile factories in the Northeast had emerged in the early 19th century, and soon after, millowners were looking to Europe and Canada for additional labor. It is estimated that one-third of the Québecois population crossed the border for work between 1865 and 1930.

Migration to Vermont and New York followed very similar patterns. The textile mills in Winooski and Burlington, Vermont, tended to attract unskilled laborers, but Vermont also drew people for work in the quarries at Isle La Motte, the railroad center in Rutland, and the fertile fields of the countryside. The Adirondack Mountains in northern New York brought lumbermen from Canada. Regardless of their origin or profession, their goal was the same—French Canadians came for a better life, whether that life was as a day laborer, farmer, or blacksmith. Many immigrants thought that they would return to Canada once they had improved their financial standing, and some

did. Others traveled back and forth across the border, living in communities on both sides as it suited their needs. Some were shocked by how difficult the work was in the mines and factories. Others felt like strangers in a strange land after leaving the only home they had known. The stabilizing force for many recent immigrants was their faith.

French Canadians looked to the comforts of religion to make the transition to the United States easier. They worshipped with Irish Catholics in established churches or met in groups at someone's home, and traveling priests would say Mass in rural outposts. Because the Irish were not always welcoming to the French, sometimes requiring that they be seated in the back and recoiling from the idea of a French priest, the French constructed their own churches. The first French Roman Catholic parish in Burlington, St. Joseph's, was established in 1850. The first French Catholic church in New York was also St. Joseph's. It was built in 1845 in Coopersville (Corbeau), New York, near the Canadian border.

The 1850s are the first time that one begins to see parishes that were largely segregated by ethnicity. Mostly French churches in Champlain and Plattsburgh, along with those that would follow in Winooski, Keeseville, St. Albans, and other places, became the focal points of immigrant neighborhoods and provided the spiritual and moral support necessary to sustain a strong Catholic presence in both states. This decade also saw the appointment of Louis deGoesbriand, the first Catholic bishop to serve the northern border. He was a native of France, and as bishop of Burlington, deGoesbriand pushed for the recruitment of French priests to serve the French Canadian populations in the north.

French Canadian parochial schools came hand-in-hand with French Canadian churches. The next generation was served by schools attached to the local parish, which allowed the French to guide the development of their young in their own faith, with their own values, and without complete assimilation into mainstream society. If the French were forced into public schools, they feared the permanent loss of their language and customs as children would only be taught in English and only learn English history. French Catholic parochial schools often taught only in French or taught half the day in French and half in English.

In addition to the church, French Canadians organized numerous mutual benefit organizations to assist those in need. They created a safety net against the dangers of the factory system and the mines and the mercurial weather faced by farmers. Moreover, they served as a mechanism for celebrating and preserving the French language, cuisine, music, folklore, and customs. Groups such as La Ligue du Sacré Coeur, Les Chevaliers de Champlain, Club Rochambeau, Canado-Americans, the Union Saint-Jean-Baptiste, St. Anne Society, and Les Enfants de Marie, along with many others, all played a role in keeping the French culture alive and well.

With the church and fraternal organizations bolstering French Canadian immigrants, populations rose throughout the second half of the 19th century and into the 20th. French Canadians are known for their large families, which helped fuel the rise in population. The precedent for large families began in Québec before World War I, when *la revanche du berceau*, or "the revenge of the cradle," was used to combat English dominance by asserting a right to the land through an ever-expanding population. By the 1930s, up to 40 percent of the population of Burlington, Vermont's largest city, was Franco-American. Even in 1970, as immigrants became more fully assimilated, fully 13 percent of the state's population still listed French as its native language in the US Census. The church and social organizations were successful in keeping the French culture alive. This is also true in northern New York. In the 1990 US Census, people who identified as French Canadians still made up the largest ethnic group in Clinton County.

The Champlain Valley is permeated with the signs of French settlement. From the names of towns and prominent landmarks to the culture that infuses society, French influence is omnipresent. Chazy, New York, and the Great and Little Chazy Rivers are named for a 17th-century French officer; Vergennes, Vermont, is named for the Comte de Vergennes, the French foreign minister who sided with the rebels during the Revolutionary War; and Rouses Point, New York, is named for Jacques Rouse, a French Canadian Revolutionary War veteran who settled in New York in the 1780s. Isle La Motte on Lake Champlain is named after Pierre LaMotte, a French soldier who built

a military outpost there in 1666. Even the name of the state of Vermont comes from the French *Vert Mont,* or Green Mountain. Many of the people who live in these places bearing French names have French surnames. They are descended from French Canadian pioneers, and some of them continue to preserve the faith, rituals, music, folklore, and language of their ancestors.

French Canadian culture has become inextricably entwined with that of the Lake Champlain region, even if French Canadian contributions have not always been as heralded by the history books as those of the British or other ethnicities. Franco-Americans were often a quiet presence, but their subtle and enduring legacy is evident throughout northern New York and Vermont. The photographs in this book tell some of their story.

Two

LEADERS AND CITIZENS

Since it is impossible to document the hundreds of thousands of French who settled in the Champlain Valley from New France, the brief stories of a few will serve as representative of a much larger group. Some were intrepid souls who followed in the footsteps of Samuel de Champlain and faced an untamed wilderness and Native Americans long before America was a country. Those who came later, in the 19th century, faced a life of hard work and, often, prejudice and discrimination. Some proudly served their country in the military or government or distinguished themselves in business or a trade. Others were part of the larger French Canadian community of laborers who helped to build the United States in the northern reaches of New York and Vermont. Religious leaders, immensely important to Franco-Americans, are covered in the next chapter.

The surnames of the men and women identified herein will not always be easily identifiable as French because many have been changed over the years. They were changed by well-meaning families hoping to assimilate into Anglo culture by translating their names into English, government employees who were unable to decipher and spell a foreign name, and fellow citizens who adopted a phonetic spelling of names they could not understand. Many names that one sees on the census rolls for places like Waterford, New York, and Swanton, Vermont, are poor imitations of the French original. Asselin became Ashline, Chartier became Carter, Poissant became Fish or Fisher, Godin became Gordon, and La Pierre became Stone. Throughout the book, when a surname is an Anglicized version of a French name, the reader will find the probable original name in parentheses after it.

The beauty of French surnames may have morphed into more mundane Anglicized versions, but the contributions of the French to their communities should not be underestimated because their names have been attenuated. French Canadians in the Champlain Valley were pioneers in their fields, valiant in their support of their new country, and determined in their work to build America. This chapter gives just a few examples of their contributions.

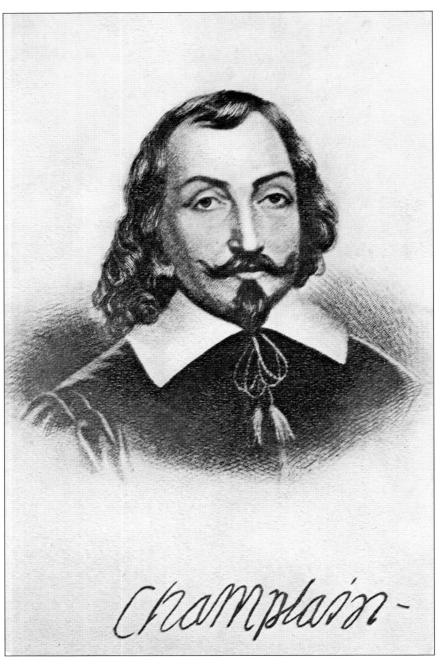

Samuel de Champlain is memorialized as the "Father of New France," and many places, streets, and structures in northeastern North America bear his name or have monuments established in his memory. The most notable of these is Lake Champlain, which straddles the border between northern New York and Vermont. In 1609, he led an expedition up the Richelieu River and explored a long, narrow lake situated between the Green Mountains of present-day Vermont and the Adirondack Mountains of present-day New York; he named the lake after himself as the first European to map and describe it. (Courtesy Samuel de Champlain History Center.)

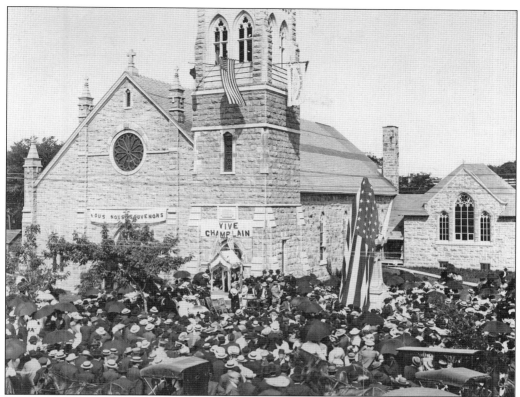

Some 6,000 visitors descended on Champlain, New York, on July 4, 1907, for the dedication of the Champlain Monument, the first in the United States, outside St. Mary's Church (above). The entire village was decorated for the occasion with American flags and the tricolor of France. The *Champlain Counselor* reported that "American and French citizens united to celebrate an event equally glorious to both nations." The banners on the church read "Vive Champlain" and "Nous nous souvenons." Members of many local societies and organizations marched in a grand parade through the principal streets of Champlain. Some wore sailor costumes to honor one of the greatest navigators of the 17th century (below). (Both, courtesy Samuel de Champlain History Center.)

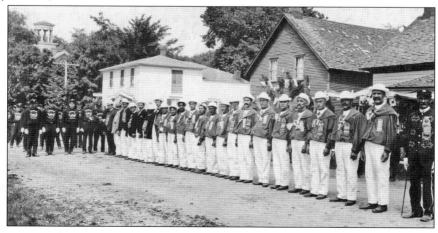

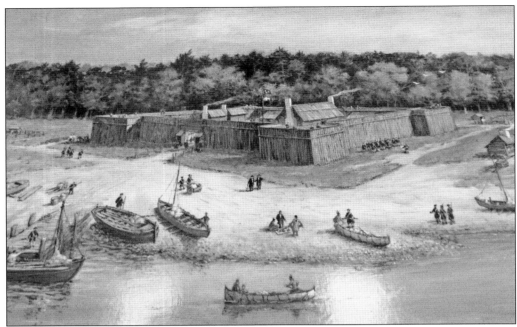

Residents in New France were perpetually concerned about the danger posed by the Iroquois confederacy and petitioned the French government for protection. In 1665, the Carignan-Salières Regiment, the first French regular troops in Canada, arrived. In 1666, Capt. Pierre La Motte oversaw the construction of Fort Ste. Anne on Isle La Motte, Vermont, shown above. Of the 1,200 men sent, over 450 settled in Québec, and many French Canadians can trace their lineage to one of these soldiers. It was here that the Jesuits celebrated the first mass and erected the first chapel in Vermont. (Above, courtesy Isle La Motte Historical Association; below, courtesy Samuel de Champlain History Center.)

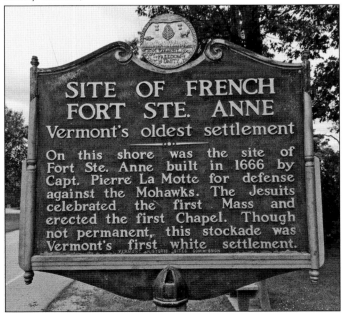

This marker denotes the site where a French officer, Capt. Nicolas de Chézy, a member of the Carignan-Salières sent by King Louis XIV, was killed by Mohawk Indians in 1666. The town of Chazy, New York, and the Great and Little Chazy Rivers were named in his honor. (Courtesy Samuel de Champlain History Center.)

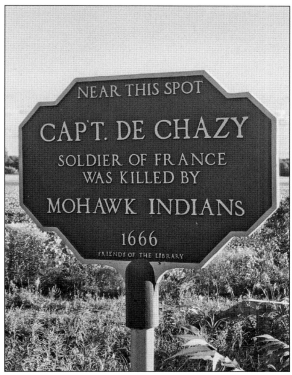

Antoine Paulint, from Isère, France, came to New France (Canada) to fight in the Seven Years' War against the English. He eventually served in a regiment of Canadian volunteers during the American Revolution. Veterans of the Canadian regiments were given land grants in the upper northeast corner of New York. Paulint's grant was in the town of Champlain (Coopersville), where he settled with his family after the war. (Courtesy Dr. Susan Ouellette.)

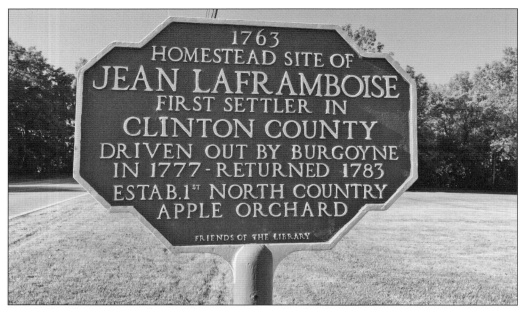

Jean Laframboise, a French Canadian, is purported to be the first European settler in Clinton County. Land records indicate that while Laframboise visited the area in 1763, as suggested by this historical marker, he did not have a permanent home in the town of Chazy until 1768. (Courtesy Samuel de Champlain History Center.)

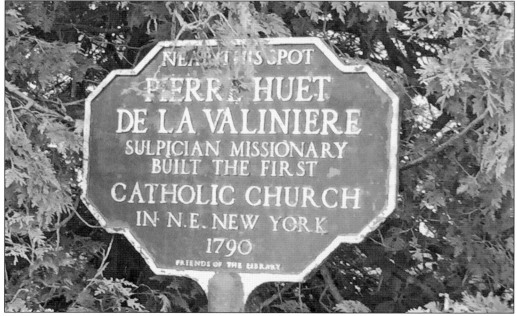

Pierre Huet de la Valinière, a Roman Catholic priest from Varades, France, arrived in New France in 1754. He was expelled in 1779 over suspicions that he sympathized with the Americans over the king of England. He returned to Québec in 1785 only to be expelled again. He moved to the United States in 1790 and built the first Catholic church in northeast New York at Split Rock. (Courtesy Samuel de Champlain History Center.)

Fanny Allen (right) was the daughter of Gen. Ethan Allen, best known as the leader of the Green Mountain Boys during the Revolutionary War. She converted to Catholicism and joined the Religious Hospitallers of St. Joseph, which was founded in La Fleche, France, and opened a center in Montréal in the mid-17th century. Her conversion was unusual, as the state of Vermont was largely Protestant at that time. She was reported to be the first Catholic nun born in New England. The Religious Hospitallers of St. Joseph ultimately opened a hospital in Burlington, Vermont, and named it in her honor (below). (Right, courtesy St. Michael's College; below, courtesy Joseph Perron.)

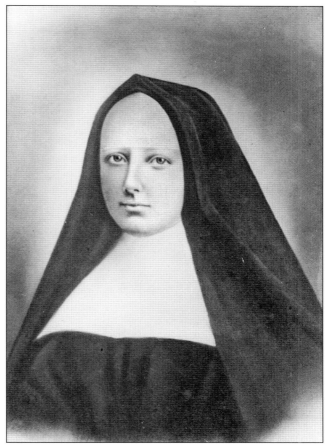

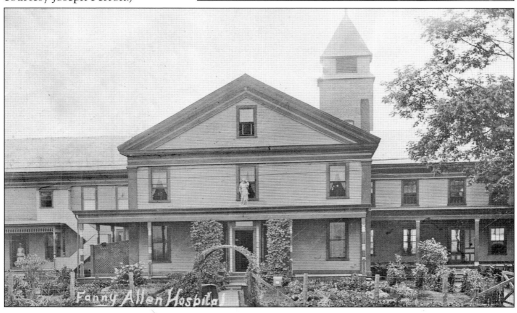

Fanny Allen Hospital

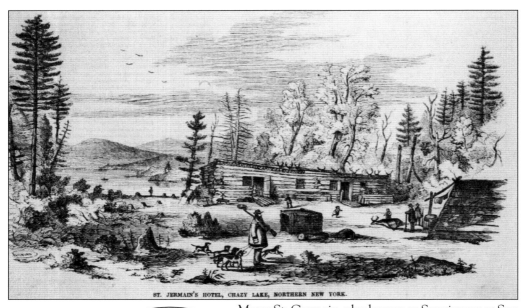

ST. JERMAIN'S HOTEL, CHAZY LAKE, NORTHERN NEW YORK.

Moses St. Germain, also known as Sangimaux or San Je Mo, a phonetic pronunciation of St. Germain, was thought to be the first settler of Chazy Lake, New York. This image of his cabin appears in the April 1858 *Ballou's Pictorial* and the related article describes St. Germain as a backwoods French Canadian squatter. Hunters and other visitors would stay at his cabin, earning it the name Hotel St. J[G]ermain. (Courtesy Kimberly Lamay Licursi.)

Between 1820 and 1830, Peter Fleury's parents came to Isle La Motte, Vermont, from Québec. Fleury owned and operated a blue limestone and French gray marble quarry and became a prominent citizen of Isle La Motte. He served as town selectman for many years and as a representative in the Vermont State Legislature. (Courtesy Isle La Motte Historical Society.)

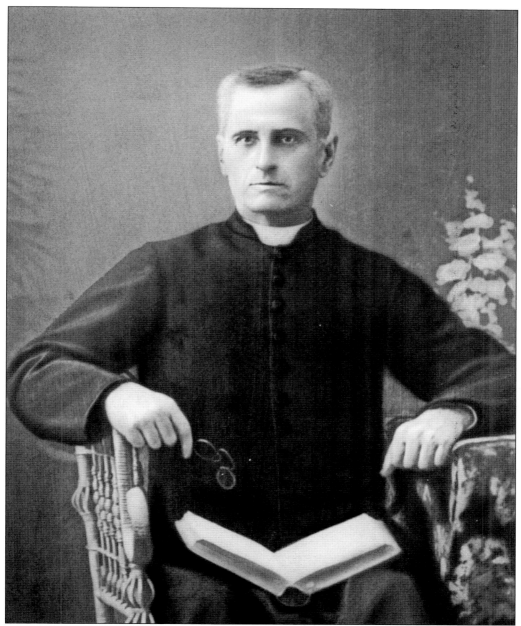

Francois-Xavier Chagnon was born in Verchéres, Québec, in 1842 and appointed pastor at St. Mary's Church, Champlain, New York, in 1870. He was a staunch supporter of Franco-Americans and a significant force in activities to promote and sustain the Franco-American culture. During his 34 years in the parish, he opened a Catholic school and in 1906 initiated the arrival of the Daughters of the Charity of the Sacred Heart of Jesus, who taught for over 100 years in Champlain. The construction of the new church began under Chagnon's leadership. He was also instrumental in the erection of the first monument to Samuel de Champlain in the United States on July 4, 1907. He died on October 10, 1911, and his tomb is located near the Champlain monument on the church grounds. (Courtesy Assumption College.)

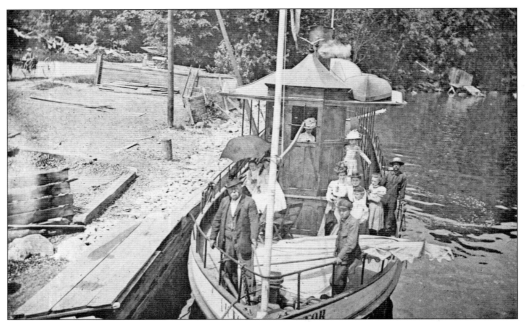

Philomena Ostiguy dit Domingue was purportedly the first licensed female steamboat pilot in the world. She can be seen in the pilothouse in this photograph wearing white clothes and a large hat. Captain "Phil" was born in St. Mathias, Québec, in 1843 and came to Vermont with her family in the 1850s. She married into a boating family in Vergennes, Vermont, in 1862 and spent much of her life thereafter on the water. (Courtesy Bixby Library, Vergennes.)

Edmund Ladabouche was one of the first Catholic settlers in Proctor, Vermont. He came from St. Hyacinthe, Québec, as a young boy before the Civil War and later became a dealer in meat, fish, fruits, and vegetables. His son, Napoleon Bonaparte Ladabouche, ran the local livery and Proctor Inn in the early 20th century. This photograph, marked "Proctor Ladabouche Children," probably depicts descendants of Edmund Ladabouche. (Courtesy Rutland Historical Society.)

At right, Francis La Prairie from Chazy, New York, enlisted in the 96th New York Infantry during the Civil War. Two other relatives joined in Franklin County. The La Prairies would have been at the Battle of Fair Oaks, a bloody affair that lasted three days. Francis survived the war and later died in Altona, New York. Historians have estimated that anywhere between 10,000 and 20,000 Franco-Americans and French Canadians fought in the Civil War. Below, Lewis Barttro (Berthiaume), a native of Québec, served with the 13th Vermont Regiment at Gettysburg and survived the onslaught of Pickett's Charge. After the war, he returned to his wife, Julia Bliss (Duplessis), in Richmond, Vermont, where they had 18 children. According to one Vermont officer, "French Canadians make the best soldiers . . . [are] more enduring, find the least fault, and have the most manhood." (Right, courtesy Clinton County Historical Association; below, both courtesy John Fisher.)

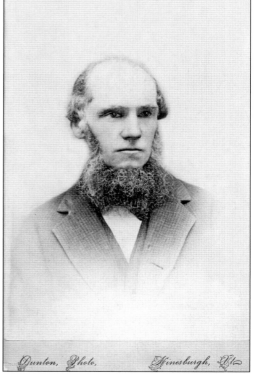

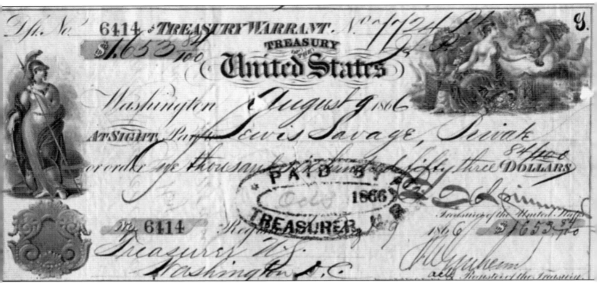

Cousins Abram Snay and Lewis Savage served in the 16th New York Volunteer Cavalry during the Civil War. Both were from French Canadian backgrounds and enlisted in Plattsburgh, New York, having no idea how acclaimed their regiment would become. Fifteen or sixteen of the members of the 16th New York would become known as "Lincoln's Avengers." In April 1865, a group of soldiers along with some detectives killed Pres. Abraham Lincoln's assassin, John Wilkes Booth, and captured Booth's accomplice David Herold. Both would be eligible for a sizeable reward. Savage's check for his service to country (pictured) was for $1,653. (Courtesy Jan Couture.)

Sons of Francois Xavier Garand and Rose de Lima Paré, Msgr. Phileas Garand (right) and his brother, Fr. George Garand (below), were born and raised in Perry's Mills (Champlain), New York. Monsignor Garand was born in 1865, attended Catholic elementary and secondary school in Champlain, and then studied in Montréal, followed by St. Joseph's Seminary in Troy, New York. He was ordained a priest in the cathedral at Albany in 1889. He served parishes of the diocese of Ogdensburg for several years before being appointed vicar general by the bishop in 1922. Monsignor Garand wrote an exhaustive 400-page *History of the City of Ogdensburg*, which was published in 1927. Father Garand also served diocesan parishes and is buried in St. Patrick's Cemetery in Rouses Point, New York. (Both, courtesy Jane Béchard West.)

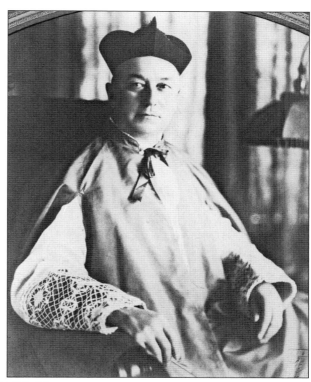

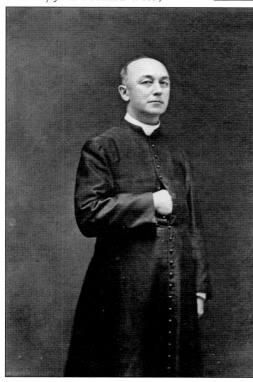

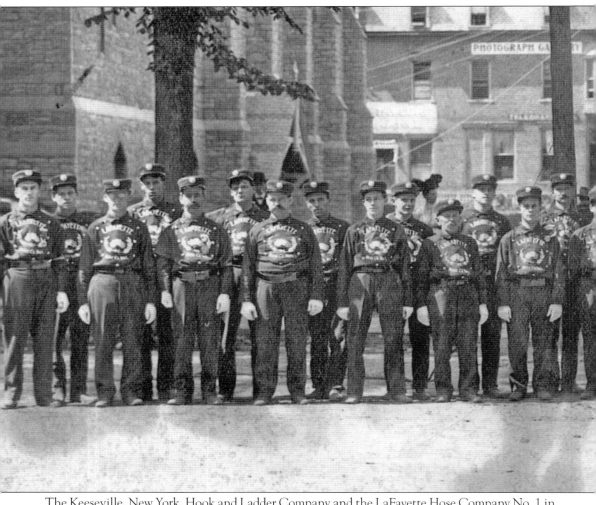

The Keeseville, New York, Hook and Ladder Company and the LaFayette Hose Company No. 1 in Plattsburgh, New York (pictured) demonstrate the strong French presence in these communities. The Lafayette Hose Company was housed in Plattsburgh's French Quarter on Montcalm Avenue and was composed mostly, if not entirely, of French Canadian men. This allowed the French

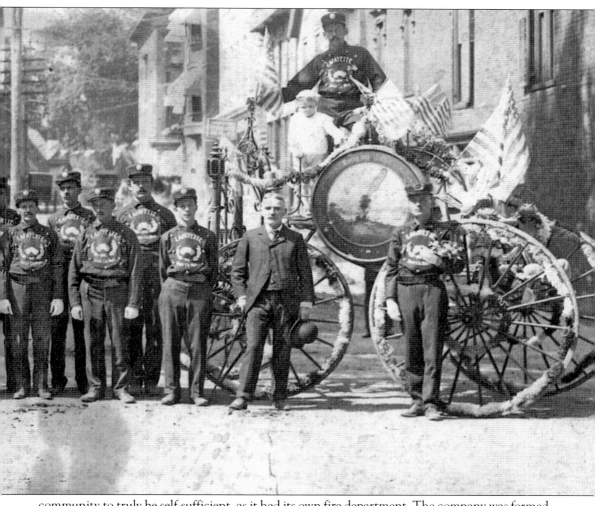

community to truly be self-sufficient, as it had its own fire department. The company was formed in 1872, and this photograph was taken in approximately 1904. (Courtesy Clinton County Historian's Office.)

The Keeseville, New York, Hook and Ladder Company includes, from left to right, Fred Stone, Fred Sharland, Joe Lesperance, George Sharrow, Fred Galarneau, "Gipi" Bonville, Nelson Miner, Peter Gordon, ? Young, Napoleon Poirer, Ed Dumoullin, Fred Rouger, William Riley, Joe Rondeau, Alfonse Abare, ? St. Louis, Joe Barber, George Lasser, Peter Sequin, George Gordon, George Bonville, and Nelson LaDuke. At least 14 of the last names are of French Canadian origin. (Courtesy Anderson Falls Historical Society.)

Dr. Joseph LaRoque owned this house on Oak Street in Plattsburgh, New York, and was one of Plattsburgh's most respected French Canadian citizens. He was born in Montréal, Québec, and in 1878 settled in Plattsburgh, where he opened a drugstore and medical practice. In the 1880s, he was also a village trustee, an unusual position of power for someone of French Canadian ancestry. (Courtesy Clinton County Historical Association.)

Jessie LaFountain Bigwood was the first woman lawyer in Vermont. She was born in 1874 to Frank LaFountain and Helen Payette and joined the Vermont bar in 1902—eighteen years before women won the vote in 1920. She lived in both Burlington and Winooski, Vermont, before moving to Toronto, Ontario, around 1908. (Courtesy John Fisher.)

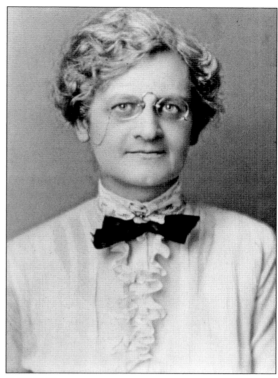

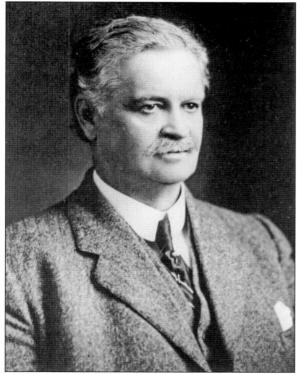

Louis-Camille Lafontaine from Champlain, New York, was the only French Canadian member of the New York Tercentenary Commission celebrating Samuel de Champlain's exploration of Lake Champlain. He was instrumental in procuring a bronze bust from famed French sculptor Auguste Rodin as a gift from France for the Champlain Memorial Lighthouse in Crown Point. He also worked to erect the first monument to Champlain in the United States in Champlain, New York. (Courtesy Samuel de Champlain History Center.)

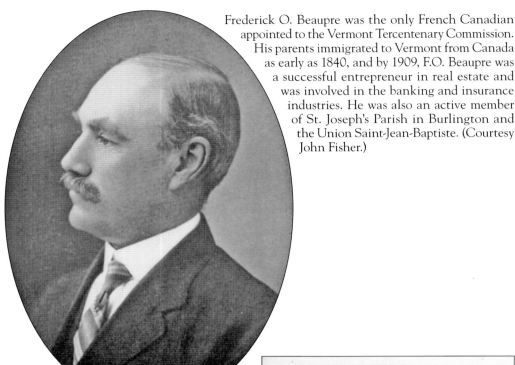

Frederick O. Beaupre was the only French Canadian appointed to the Vermont Tercentenary Commission. His parents immigrated to Vermont from Canada as early as 1840, and by 1909, F.O. Beaupre was a successful entrepreneur in real estate and was involved in the banking and insurance industries. He was also an active member of St. Joseph's Parish in Burlington and the Union Saint-Jean-Baptiste. (Courtesy John Fisher.)

This 1921 guide sought to champion the contributions of Franco-Americans during the Great War. The introduction notes that the book will demonstrate that Franco-Americans will always fulfill their duty because the cause of America is theirs and they are not foreigners in the United States. It is a 500-page document listing the names of those who served by state and town or village. (Courtesy Kimberly Lamay Licursi.)

GUIDE
Franco-Americain
1921

Les Franco-Americains
et
La Guerre Mondiale

Publié par
ALBERT A. BELANGER
Fall-River
Mass.

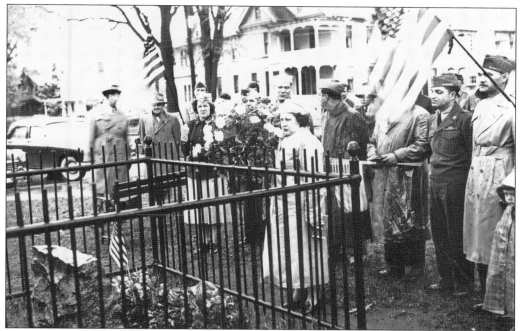

The Veterans of Foreign Wars remembered the first Vermont casualty of the war, Howard W. Plant (Plante), by naming the Burlington post in his honor. Seaman Plant was on the destroyer USS *Jacob Jones* when it was sunk by a submarine in the Atlantic Ocean. In this photograph, Burlington residents gather in Battery Park on the 40th anniversary of his death in 1957. (Courtesy University of Vermont Special Collections.)

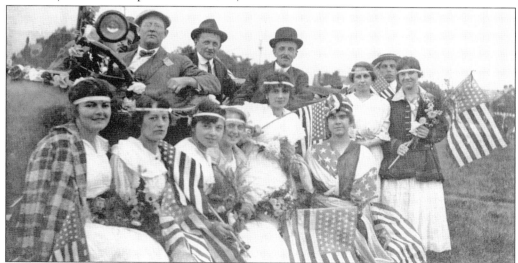

In August 1916, French Canadian workers crafted a prizewinning float in the second annual parade and field day of the American Woolen Company in Winooski, Vermont. Alfreda Fisher, dressed as Liberty (seated with flag wrapped around her head), and her escorts earned second place. On the float are (back row first) Jean Baptiste Chevrier, a Mr. Simar, a Mr. Efager, a Mr. Peace, a Mr. Lesage, Louisa Germain, Emelia Beauchemin, Ireine Bourassa, Rose Brunelle, Cora Bordeau, Eva Gautier, and E. Companion. (Courtesy John Fisher.)

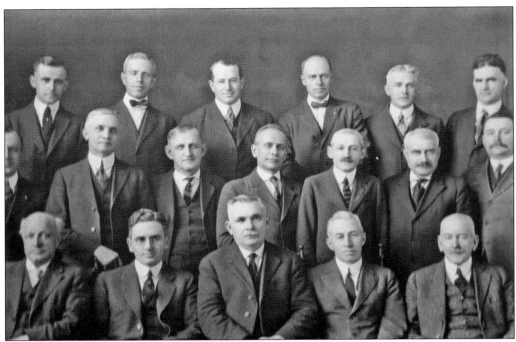

Ezra Trepanier is fourth from left in the middle row in this 1920–1921 photograph of the Clinton County Board of Supervisors. Trepanier and his wife, Hortense Ashline (Asselin), were well-respected citizens of Champlain, New York. Trepanier served two terms in the New York State Assembly as well as a term as the supervisor of the town of Champlain. He also owned a grocery business in Champlain. (Courtesy Clinton County Historian's Officer.)

Pictured at left is Leander Bouyea, who served as the 14th mayor of the city of Plattsburgh, New York, from 1932 to 1943. Other Franco-Americans who served as mayor of the city include Albert J. Sharron (the first mayor, 1902–1903), Joseph Payette (1907), Dr. Andrew G. Senecal (1910–1911), Rev. Roland St. Pierre (1972–1977), and Clyde M. Rabideau Jr. (1990–1999). (Courtesy Mayor's Office, City of Plattsburgh, New York.)

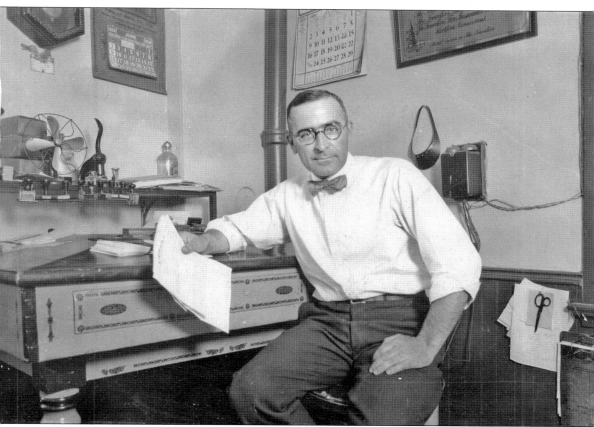

Pictured is William Paquette, a lifelong citizen of Champlain, New York. Bill was born into a canal boating family in 1890 but left the boating business to work in a hardware store. He eventually founded Paquette's Insurance Agency in 1927. Paquette was a prominent and respected citizen who served on several boards and was Village of Champlain clerk from 1934 to 1952, Clinton County clerk from 1937 to 1951, trustee and president of the Champlain Central School Board in the early 1940s, and a founding member of the Father F.X. Chagnon Council of the Knights of Columbus as well as being a member of St. Mary's Parish in Champlain. For many years, Paquette assisted French Canadians with their citizenship applications. He died in 1965. Paquette Park, dedicated in 1973 in Champlain, is named for him and his son, Lawrence Paquette. (Courtesy Samuel de Champlain History Center.)

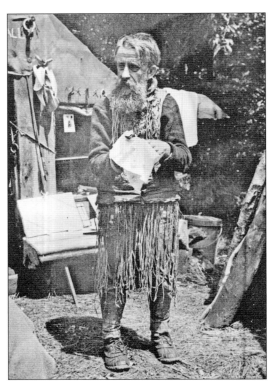

Noah Rondeau gained some acclaim in the 1930s and 1940s as the hermit of the Adirondacks. He ran away from his home near Ausable Forks, New York, in 1900 and spent many years as a handyman and guide in the western Adirondacks before giving up on civilization in 1929. Rondeau relocated to the Cold River area and lived in the wilderness for over 20 years. (Courtesy Samuel de Champlain History Center.)

Jean Baptiste Montagne and Eva Catherine Richer, pictured here on their wedding day, came from Stanbridge East, Québec, to a farm on the Kellogg Road in St. Albans in 1925. They had 17 children who attended Holy Guardian Angels School, where the nuns were mostly bilingual Québecoises. Four of their sons—Paul, Joffre, Jacques, and Marcel—fought in World War II. (Courtesy St. Albans Historical Museum.)

Dr. Isidore A. Boulé (right), a dentist, was named a trustee of St. Peter's Church (Église St. Pierre) in Plattsburgh, New York, in 1932 and served in that position for over 20 years. In 1952, Leo Denicore (below), a prominent businessman, was appointed a trustee of St. Peter's Church. Franco-Americans generously served as trustees in their parish churches, fulfilling this very important role. (Both, courtesy St. Peter's Church, Plattsburgh, New York.)

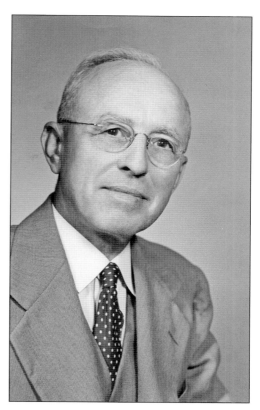

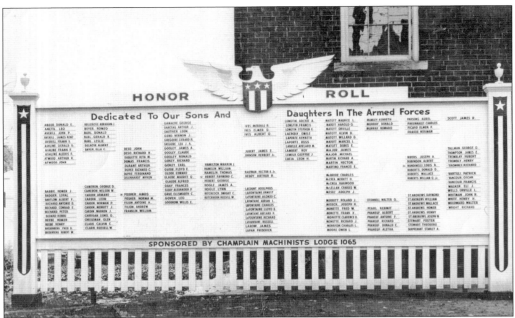

This honor roll, once located outside the town hall in Champlain, New York, was dedicated to those who served in the armed forces during World War II. The preponderance of French names bears witness to the zeal with which French Canadians fought for their adopted country. The panel was sponsored by the Champlain Machinists Lodge 1065 and was dedicated in October 1947. (Courtesy Samuel de Champlain History Center.)

Lt. Thelma LaBombard served in the Navy Nurse Corps during World War II. She received her nursing education at Bishop Louis deGoesbriand Hospital in Burlington, Vermont. LaBombard was posted at Pearl Harbor, Hawaii, and the British Virgin Islands during her tenure with the Navy. She was a resident of Isle La Motte. (Courtesy Isle La Motte Historical Society.)

Dr. Arthur B. deGrandpré (right), born in Plattsburgh in 1909, graduated from Georgetown Medical School in 1932. During World War II, he served in the US Army for three years in the European, North African, and Italian theaters of operation. He had an active surgical practice in Plattsburgh for over 55 years. Dr. A.B. deGrandpré was known not only for his surgical skills but also for his kind and dignified manner. He and his wife, Jane, were the parents of eight children. Pictured below, from left to right, are Dr. A.B. deGrandpré; a friend; and Alexandrine and Dr. Arthur Amédée deGrandpré, the mother and father of Dr. A.B. and Dr. Gerard deGrandpré. Kneeling in the front is Dr. Gerard deGrandpré. (Both, courtesy Christopher B. deGrandpré.)

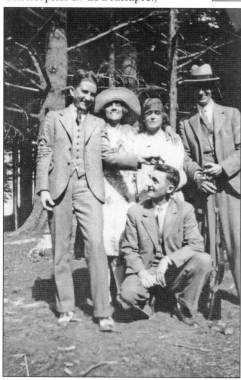

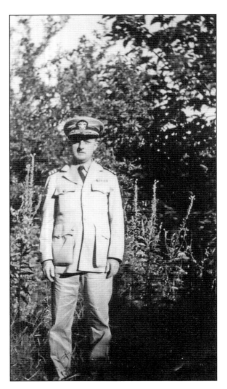

Dr. Gerard deGrandpré, born in Peru, New York, in 1897, graduated from the University of Vermont Medical School in 1924. During World War II, he served in the Navy for three years and emerged with the rank of captain. He was a highly respected surgeon in Plattsburgh, where he served on the attending staff of the Champlain Valley Hospital. (Courtesy Christopher B. deGrandpré.)

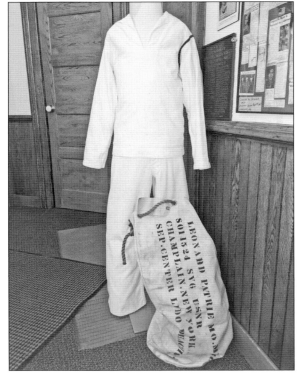

This uniform and rucksack were donated by the family of Leonard Patrie Sr., who joined the Navy on December 14, 1943, as part of an armed guard unit. He was employed at Sheridan Iron Works and lived in Champlain, New York, all his life. The uniform and bag are on display at the Samuel de Champlain History Center. (Courtesy Samuel de Champlain History Center.)

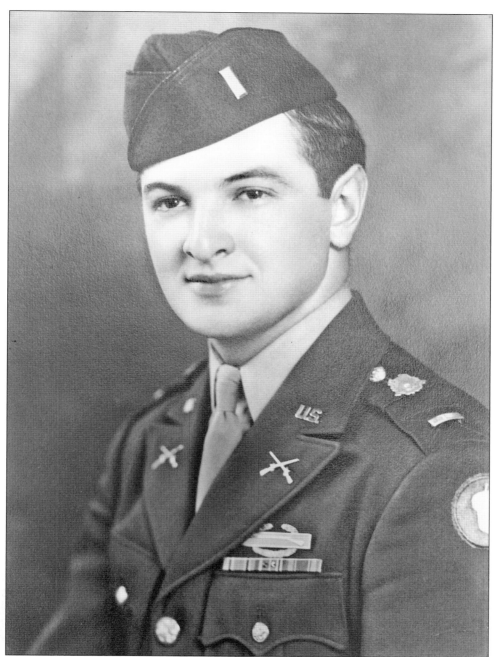

Robert Picher grew up in a French-speaking Winooski household, well connected to the French community through his father's leadership in the Union Saint-Jean-Baptiste. Picher left Assumption College in 1942 to enlist in the Army during World War II. He fought at the Battle of the Rhine and in central Germany before helping to liberate the Buchenwald concentration camp near Weimar, Germany. After the war, he continued his service in the Vermont National Guard, leaving the guard as a two-star commanding general. Picher became a prominent attorney in Winooski in addition to serving in local politics. (Courtesy Robert Picher.)

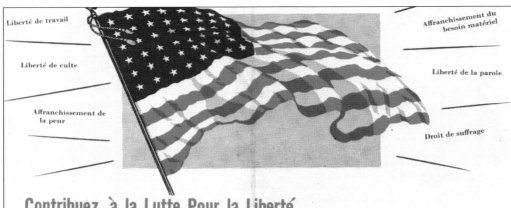

Liberté de travail

Affranchissement du besoin matériel

Liberté de culte

Liberté de la parole

Affranchissement de la peur

Droit de suffrage

Contribuez à la Lutte Pour la Liberté

En Faisant des Épargnes

Raisons pour lesquelles vous devriez acheter votre part de Timbres et Bons de Guerre.

 Votre pays combat pour votre sécurité, pour votre vie. Pour gagner la guerre et vous proteger, vous et votre foyer, contre les bombardements aériens nous devons faire des milliers et des milliers de canons, d'avions, de chars d'assaut et de vaisseaux. Tout cela coûte énormément cher. Les Bons et Timbres de Guerre que vous achetez contribuent à nous procurer MAINTENANT les moyens de combat nécessaires à nos soldats. Chaque Américain devrait faire des épargnes à cette fin. Tous ceux qui ont un emploi devraient mettre de côté au moins 10 pour cent de leur salaire à chaque jour de paye afin d'aider le gouvernement à gagner la guerre.

Savez-vous ceci?

Quand vous achetez des BONS DE GUERRE vous ne donnez POINT—Vous effectuez un placement AVANTAGEUX!

Savez-vous ceci?

Les BONS DE GUERRE vous rapportent 2.9% d'intérêt!

Savez-vous ceci?

Vous pouvez commencer à constituer le montant nécessaire à l'achat de Bons de Guerre en vous procurant des Timbres de Guerre qui ne coûtent que 10c chacun.

Savez-vous ceci?

Un Bon de Guerre de $25 (valeur nominale), ne vous coûte que la modique somme de $18.75.

★ ★ ★

Savez-vous ceci?

Les placements en Bons de Guerre empêchent le coût de l'existence de s'élever.

Savez-vous ceci?

Les Bons de Guerre constituent les placements les plus sûrs dans le monde.

Savez-vous ceci?

Vous recevrez dans dix ans $4 contre chaque somme de $3 que vous placez en Bons de Guerre.

Savez-vous ceci?

Comme patriote américain vous devriez faire des épargnes régulièrement—chaque semaine—en achetant des Bons et Timbres de Guerre.

★ ★ ★

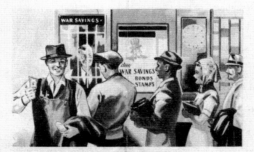

Achetez (United States) Bons de Guerre **Timbres—régulièrement**

Auprès: du bureau de poste de votre localité, de la Banque, de l'association d'épargnes et de prêts ou de la Trésorerie des É.-U. directement en faisant usage de la formule du verso; ou auprès: de votre association nationale, d'une société fraternelle, d'une organisation de secours mutuels, ou selon le Plan d'épargnes de la compagnie où vous travailles.

The number of French-speaking individuals in the northern part of New York warranted this French-language war bond solicitation flyer during the Second World War. Bond drives helped to fund the war effort in both world wars, and significant participation by all was expected. (Courtesy Samuel de Champlain History Center.)

Two

RELIGION

Nothing is more significant in the exploration of Franco-Americans than religion. Roman Catholicism dominated so much of their lives that it is impossible to fully understand French Canadians in America without appreciating the strength of their parishes. Everything tied back to their religious beliefs and bound French Canadian immigrants with a code of conduct and ritual that was consistent regardless of geography. The church was their refuge in Canada and quickly became a refuge in their new country. It provided comfort and familiarity in a time of great change.

Early-19th-century Roman Catholic churches in northern New York and Vermont usually served both Irish and French populations. However, French Canadians often faced discrimination from the Irish-dominated clergy and church leadership. To combat habitual prejudice, French Canadian faith leaders were diligent in establishing French national parishes with French-speaking priests. These were the cornerstones of cohesive church-centered French communities.

The church gave Franco-Americans a moral compass, a social network, and a buffer against the strangeness of other immigrants and New England Yankees. Because of its significance, French Canadians were incredibly generous when it came to financing church construction. While many may have had meagre incomes, when it came to their parish, it seems that their ability to give was endless. Large stone edifices with extensively decorated interiors belied the financial wherewithal of their benefactors. Small farming communities like Champlain, New York, and St. Albans, Vermont, built stone temples that seemed to far outstrip the means of their parishioners. These structures were a testament to the dedication Franco-Americans had to Roman Catholicism and their strong sense of community. And where a church was built, a parochial school was sure to follow. French churches meant French schools. Parochial schools allowed the integration of Catholicism and French Canadian values and language in the daily curriculum and guided the spiritual development of the next generation.

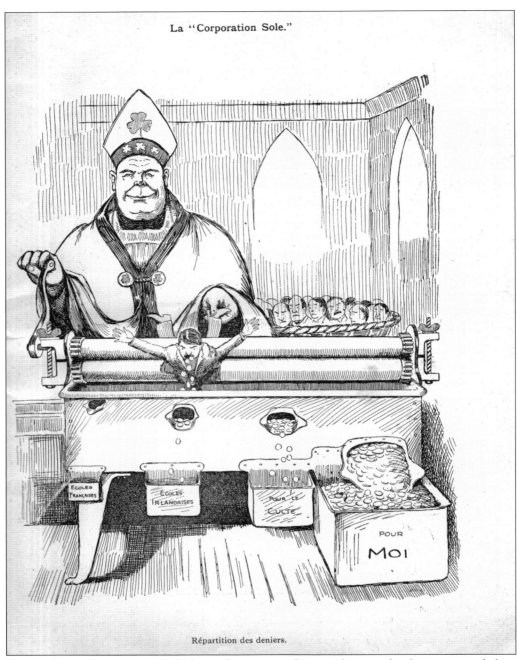

La "Corporation Sole."

Répartition des deniers.

Depicted is a gluttonous Irish bishop who squeezes his parishioners for donations and then apportions the money first for himself, then for the church, Irish parochial schools, and finally, French parochial schools. There was a real rivalry between French and Irish Catholics in New York and Vermont, each of whom was clannish and tended to disparage the other. Throughout much of the 19th century, the Irish held more leadership positions in the Roman Catholic church hierarchy, a point that aggrieved many French parishioners. (Courtesy Samuel de Champlain History Center.)

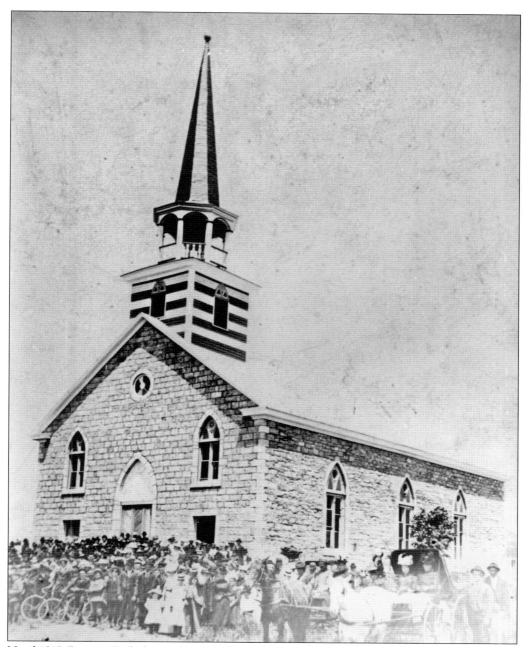

Until 1818, Roman Catholic residents in the top corner of New York could only count on sporadic religious services from traveling Canadian priests. After 1818, a rough-hewn log structure across from the present St. Joseph's Church in Coopersville (Corbeau) may have served as a place of worship until it burned down in 1823. A permanent church was begun in 1845 under Fr. Louis Lapic. When St. Joseph's Church was built (shown here as it appeared around 1900), it was the only Catholic parish north of Plattsburgh, New York. (Courtesy Samuel de Champlain History Center.)

The original St. Joseph's (above) in Burlington, Vermont, was constructed in 1850. The interior of the church is decorated to celebrate the founding of a St. Joseph's society in 1858. The growing community of French Canadians quickly outgrew the small brick church. Msgr. Louis deGoesbriand (right) was installed as the first bishop of Burlington in 1853. The son of a nobleman, he was born in St. Urbain, France. The new Diocese of Burlington encompassed all of Vermont, and deGoesbriand worked diligently to bring more French Catholic priests to the region. He believed that immigrants were in danger of losing their faith if they were not ministered to by priests who spoke French and understood their needs. He approved the construction of a bigger church for the congregants of St. Joseph's. (Above, courtesy Joseph Perron; right, courtesy Diocese of Burlington.)

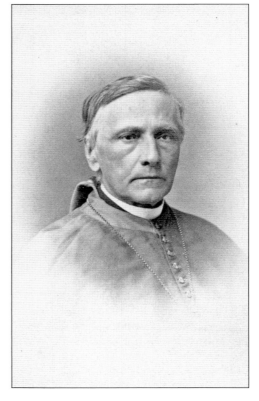

St. Joseph's in Burlington, Vermont (right), has the distinction of being a French Canadian "national parish," or a church distinguished by the nationality of its congregants. The new church was designed by Fr. Joseph Michaud in the Baroque Revival style, which along with Gothic Revival was popular at the end of the 19th century. The church reflected the designs of St. Peter's Basilica in Rome. The impressively sized church, which could fit 1,200 people, was inaugurated in 1887. The interior (below) was crafted by many skilled parishioners who donated their time to assist with the intricate decoration emphasizing grandeur and drama. These were traits associated with Baroque design. (Both, courtesy Diocese of Burlington.)

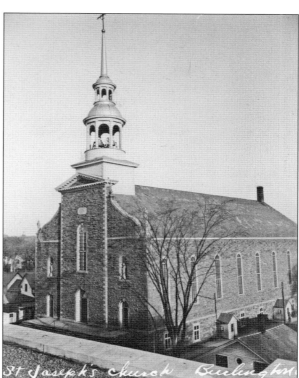

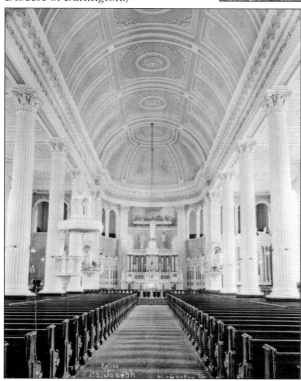

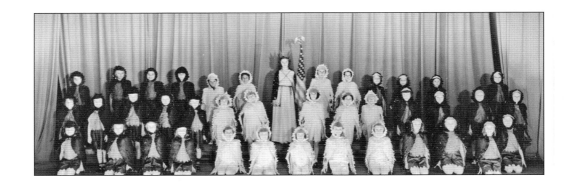

Third-grade students in the Nazareth Elementary School, part of St. Joseph's Parish in Burlington, perform *A Flag in Birdland*. The photograph above from May 1940 depicts three groups of children—white doves, red robins, and bluebirds—who would come together to form an American flag. The play was promoted during World War I as a patriotic endeavor for young children and was revived during World War II. Below is a 1925 Nazareth class photograph taken on the steps of the rectory on Elmwood Avenue. Fr. Norbert Proulx is in the center, and Fr. E. Alliot, S.S.E., of St. Michael's College is on the right. Parochial schools were an important part of keeping the French community together from elementary school through high school. (Both, courtesy Diocese of Burlington.)

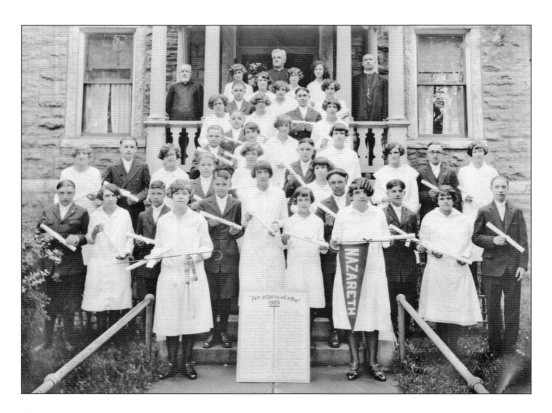

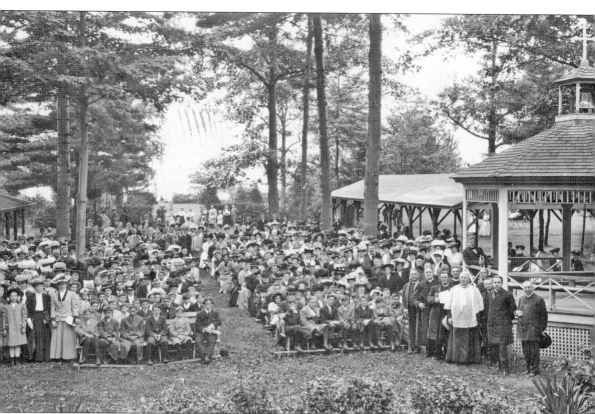

The French constructed a fort on Isle La Motte, Vermont, in 1666 and dedicated it to St. Anne. It was there that the first mass in Vermont was offered. The fort was abandoned within a few years. The Diocese of Burlington acquired the land for a chapel in 1892. The direction of St. Anne's Shrine was entrusted to the Society of St. Edmund in 1904 and subsequently purchased by the society in 1921. Since then, all modes of transportation have brought people to the shrine. This image depicts an early gathering at what is now known as St. Anne's Shrine. It was the first church or chapel dedicated to St. Anne in the United States. (Courtesy Samuel de Champlain History Center.)

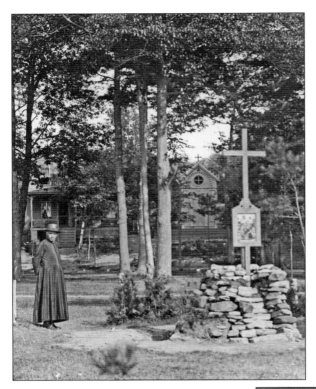

Fr. Joseph Kerlidou, born in Finistere, France, was assigned to Isle La Motte, Vermont, in 1886. A new St. Anne chapel was built on the site of the original Fort St. Anne and dedicated in 1893. A large cross, 32 feet high, was also erected, as shown in this photograph. Father Kerlidou found many relics of the ancient fort at the site. (Courtesy Samuel de Champlain History Center.)

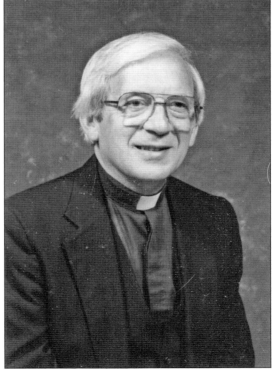

Fr. Maurice Boucher, a member of the Society of St. Edmund, served as director of St. Anne's Shrine from 1956 to 1963 and again from 1969 until his death in 2009. People remember him for his welcoming demeanor and for encouraging French Canadians to attend shrine events and pilgrimages. He was known for the successful promotion of the shrine, improving the existing buildings, and adding new facilities. (Courtesy Samuel de Champlain History Center.)

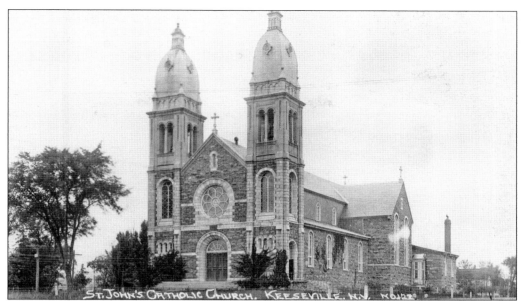

Construction began on St. John the Baptist Church in Keeseville, New York, in 1901. It was made of native granite with a 60-foot-high nave and two towers of 125 feet each. Rev. Michael Charbonneau is credited with convincing residents of the importance of investing in the grand structure. (Courtesy Anderson Falls Historical Society.)

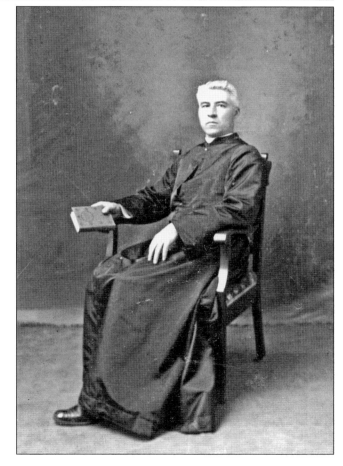

Father Charbonneau began his work in Ogdensburg, New York, where he served to soothe tensions between French Canadian and Irish parishioners. He then moved to Keeseville, where he oversaw the construction of St. John the Baptist Church. It was completed in 1902. Its design, with two towers and a rose window over the entrance, was typical of many French churches. (Courtesy Clinton County Historian's Office.)

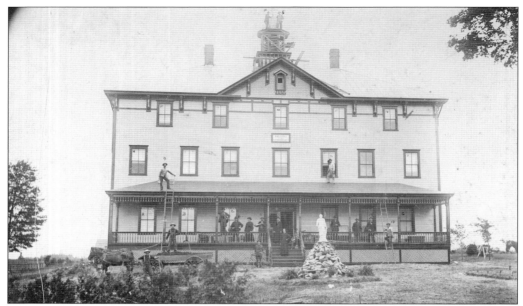

Just out of frame on the right, a French flag flies outside of this parochial school building in Swanton, Vermont. The building served at various times as the St. Edmund Society House, St. Edmund's Juniorate (junior seminary), and St. Edmund's Novitiate. A similar image identifies rooms in the structure, including the nurse's office, sacristy, and dorm for children. (Courtesy St. Michael's College.)

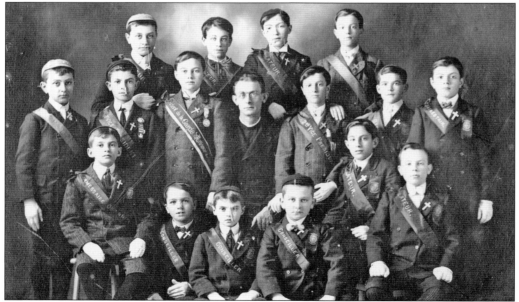

Fr. Francis X. Chagnon of St. Mary's Church in Champlain, New York, sits in the center of this photograph of young boys from April 1908. The boys are wearing sashes indicating they are part of the Saint-Jean-Baptiste Guard of Honor. Father Chagnon was well known in both New York and Vermont for his efforts with the Union Saint-Jean-Baptiste and other religious organizations. (Courtesy Samuel de Champlain History Center.)

St. Mary's Church in Champlain, New York (right), demonstrates some of the key features of late-19th-century church construction and decoration. During this era, the Roman Catholic Church looked to the medieval cathedrals of northern France for inspiration and adopted the Gothic Revival style. Churches often had twin towers and quite often had a rose window over the front entrance. St. Mary's, completed in 1887, has only one tower but has the defining window above the door. Below is an elaborate First Communion certificate issued to Hubert Laventure on June 11, 1905, in "Eglise Ste. Marie de Champlain" and signed by Fr. F.X. Chagnon, pastor. Father Chagnon's photograph is at the top left, and an image of St. Mary's Church is top center. (Both, courtesy Samuel de Champlain History Center.)

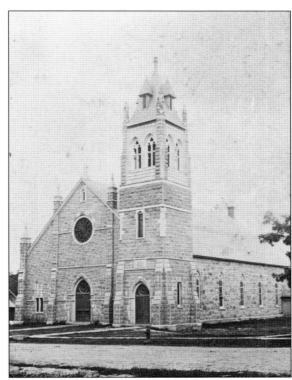

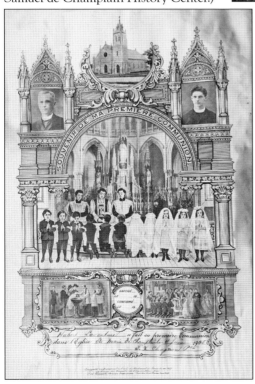

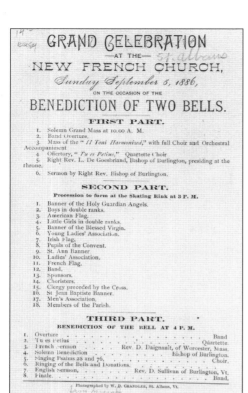

Holy Guardian Angels in St. Albans, Vermont, was established as a French national parish by Bishop Louis deGoesbriand in 1872. This program details events that were held to celebrate the consecration of the church in 1886. It boasts an organ crafted by Canadian artisans that is one of only a few remaining in New England. (Courtesy St. Albans Historical Museum.)

The interior of Holy Guardian Angels Church reflects the same traditions found in most French churches, from the elaborate altar to the ribbed ceiling. Elaborate decoration was a hallmark of the Victorian era in which most of these churches were built. The pews were often a dark stained wood contrasting with the brilliantly colored light that would filter through stained-glass windows. (Courtesy St. Albans Historical Museum.)

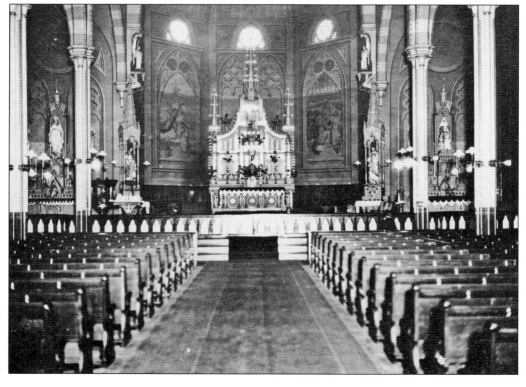

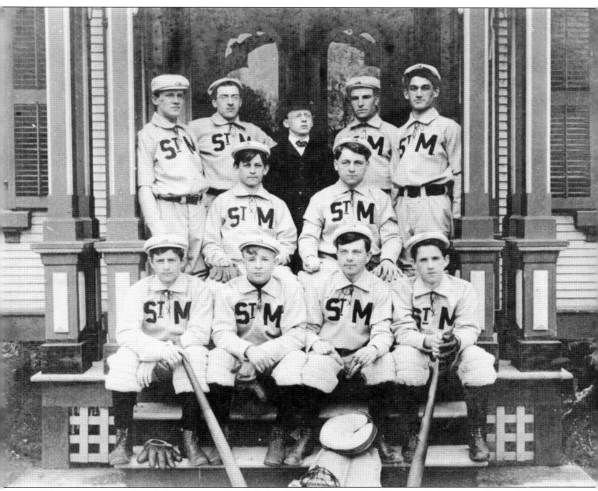

This is an early baseball team at St. Michael's College in Burlington, Vermont. From left to right are (first row) Pinard, Galipeau, Gélineau, and Ryan; (second row) M-Limoges and Obrien; (third row) B. McMahon, Labory, Barttro, Ledoux, and Pellerin. The Society of St. Edmund established St. Michael's College in 1904. The society was founded in 1843 in Pontigny, France. The Edmundites, as they are known, came to Vermont in the latter part of the 19th century from Québec to minister to French Canadians in northern Vermont. St. Michael's was the first Catholic college in Vermont. (Courtesy St. Michael's College.)

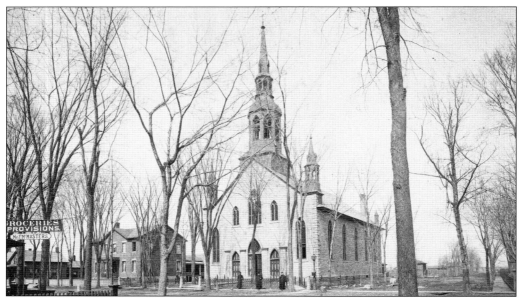

By the 1880s, the French Catholic parishioners at St. Peter's in Plattsburgh, pictured above, had established a thriving community. A history of the church notes that there were "blacksmiths (Roberts and Gonyea; Normandeau and Little), shoemakers (Louis Ducharme; J. G. Girard & Co.; Joseph Mignault), a bowling alley (M. Burdo), carpenters and builders (J. B. Dandro), carriage builders (Normandeau and Little; E. C. Trombley & Co.) door sash and blind mfg. (J. B. Dandrow), groceries (L. U. Archambault; Joseph Charbonneau; John Duval; Seymour Gallant; D. Laforce; Phillip Laplante & Andrew Senecal), harness and saddle makers (Noel Bessette and M. Laforce), a hotel (Valley House, A. Valley Prop.), leather and findings (D. Laforce), a meat market (J. Burdo), painters (Nelson Barrette; A. Gauthier), pianos and organs (Arthur Laurier), a saloon (Andrew Borde), a tanner and currier (D. Laforce), an undertaker (Edward Erno [Renaud]), and a physician (Dr. J. H. Larocque)." The photograph below depicts numerous children of the parish making their First Communion in 1907. (Above, courtesy Clinton County Historical Association; below, courtesy St Peter's Church.)

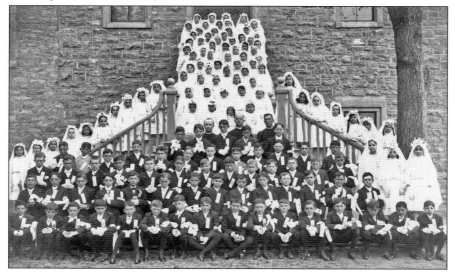

St. Peter's Parish undertook a significant restoration of the sanctuary in the 1950s, and the results are shown in the 1953 photograph at right. The church has the typical design of plaster ribs and shafts at the ceiling and a heavily decorated altar. In 1853, St. Peter's Church was organized in what would become the French Quarter of Plattsburgh, and the image below depicts a procession there in 1951. By 1881, a report noted that almost half of all Plattsburgh residents were French Canadian. Most lived on the streets of the French Quarter, including St. Charles Place, named in honor of a French bishop; Montcalm Avenue, named in honor of the French general commanding forces during the Seven Years' War; Champlain Street, in honor of the explorer Samuel de Champlain; and Lafayette Street, in honor of the Marquis de Lafayette, who fought with the Americans during the Revolutionary War. (Both, courtesy St. Peter's Church.)

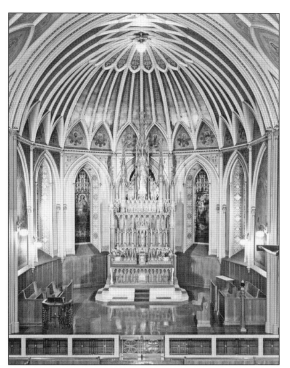

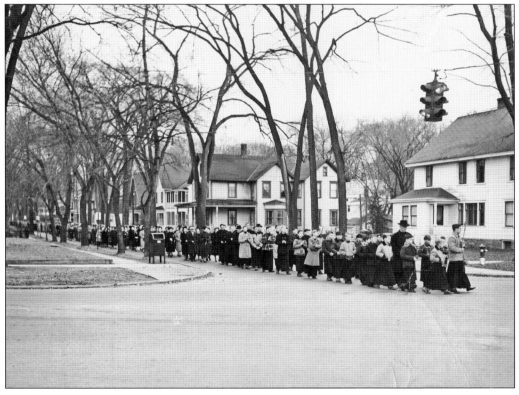

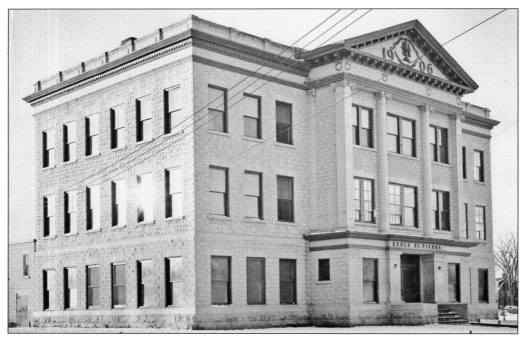

Until the 1950s, French Catholic schools like St. Peter's in Plattsburgh, New York, often used the half-day system. Students were taught for half the day in French and half in English. Students might learn math, science, history, and geography in English and French grammar, religion, Canadian history, singing, and drawing in French. The advertisement below for Academie St. Pierre in Plattsburgh notes it was "erigée par les Canadiens (erected by the Canadians) pour notre Dieu et pour nos familles (for our God and for our families)." (Above, courtesy St. Peter's Church, below, courtesy Clinton County Historian's Office.)

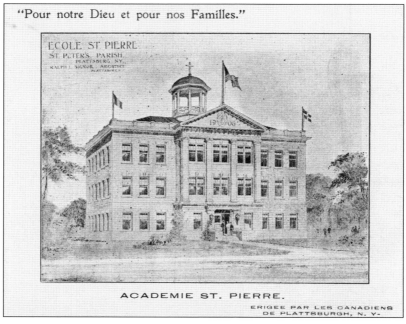

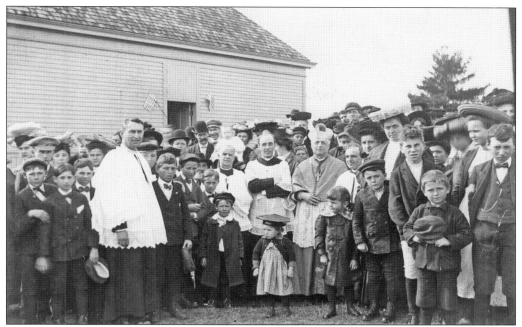

St. Peter's Church congregants and religious leaders gather for a photograph on the occasion of the confirmation of a class of parishioners. Note the American flags hung on the structure in the background. (Courtesy Clinton County Historian's Office.)

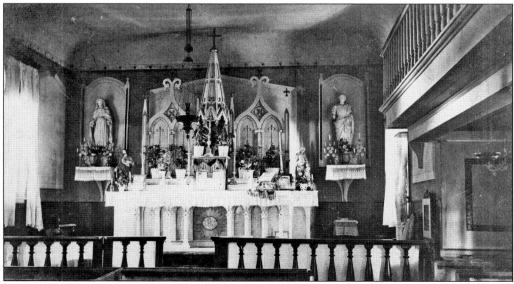

St. Alphonsus Church in Glens Falls, New York, a small wooden structure, was erected in 1853 by Father Turcotte. By 1880, the parish had increased in size enough to warrant a much larger brick and stone church constructed on the same site at the corner of Pine and Broad Streets. This photograph depicts the original interior of the church. (Courtesy Chapman Museum.)

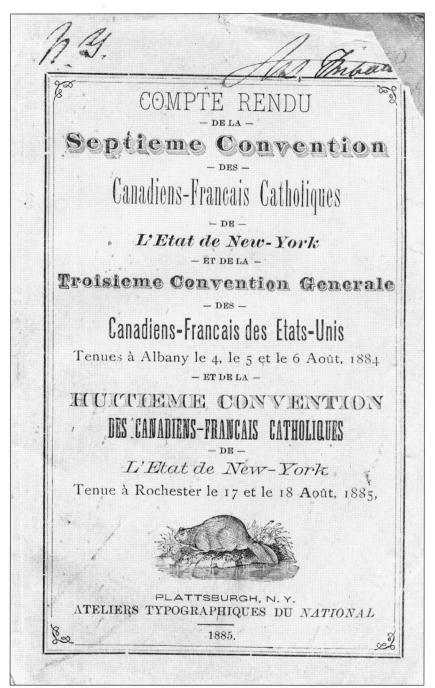

COMPTE RENDU

— DE LA —

Septieme Convention

— DES —

Canadiens-Francais Catholiques

— DE —

L'Etat de New-York

— ET DE LA —

Troisieme Convention Generale

— DES —

Canadiens-Francais des Etats-Unis

Tenues à Albany le 4, le 5 et le 6 Août, 1884

— ET DE LA —

HUITIEME CONVENTION

DES CANADIENS-FRANCAIS CATHOLIQUES

— DE —

L'Etat de New-York

Tenue à Rochester le 17 et le 18 Août, 1885,

PLATTSBURGH, N.Y.

ATELIERS TYPOGRAPHIQUES DU *NATIONAL*

1885.

Many French Canadian Catholic conventions were held in the 19th century to promote and preserve Franco-American language and culture in the face of threats from the pressure to assimilate to American culture and Irish domination of the Catholic Church. Here are the proceedings of the seventh and eighth annual conventions in 1884 and 1885 respectively, as printed by Plattsburgh's French-language newspaper, *Le National*. (Courtesy Samuel de Champlain History Center.)

Three

WORK

Many of the French Canadians who immigrated to northern Vermont and New York sought jobs in the mills, mines, or lumber camps. The rapid industrialization of the United States from the mid-19th century onward produced a continual need for cheap labor. Those who found shrinking opportunities for land ownership or employment in Québec became easy targets for labor recruitment efforts south of the border. They came to the mills in Winooski, the quarries of Isle La Motte, and the forests of the Adirondacks to meet the needs of the growing American economy. Other immigrants worked the earth as farmers. Because most had no money to purchase their own property, these farmers worked rented land or as day laborers. Regardless of the trade, in many North Country communities, Franco-Americans were the backbone of progress, if not necessarily the leading industrialists or pillars of government. They were a quiet force focused more on community and family than business and upward mobility.

When the newcomers from Canada sought housing, most chose accommodations close to their work and usually congregated together near the local mine or mill. These enclaves became known as "Little Canadas," "French Quarters," or "French Villages," usually focused around French Roman Catholic parishes. The artisans who came south would set up trade in these neighborhoods and cater to the Franco-American clientele. This allowed Little Canadas to become insular compounds where French culture and language could thrive. French druggists, merchants, doctors, and undertakers made it possible to prosper without learning English and lessened the need for assimilation into Yankee New England. In the places with the highest concentration of artisans and businessmen, like Winooski, they became a force both influential and visible; in others, they remained more covert.

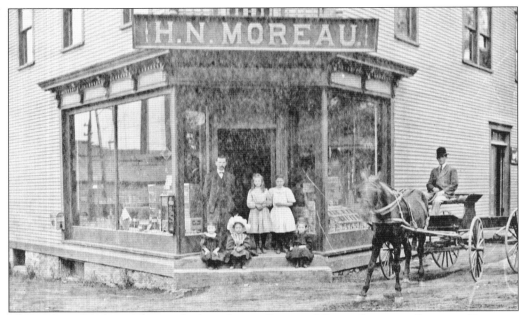

The Moreau family stands outside their shop at River and Depot Streets in Swanton, Vermont, in 1909. From left to right are Henri Moreau, Nina Shaw, Viola Tetreault, Marguerite Moreau, Exilda Cartier, Fibronia Moreau, Old Ben (the horse), and Robert Greenough. Henri Moreau worked in the grocery, hardware, and grain business in successive order. (Courtesy Swanton Historical Society.)

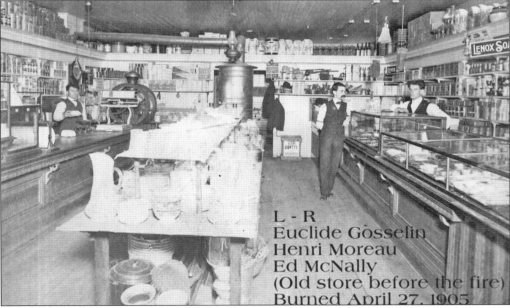

Clerks are dressed very smartly inside Moreau's grocery store in this photograph, taken before 1905. Henri Moreau (center) came to Vermont around the turn of the 20th century from Bedford, Québec. Moreau was a member of the Union Saint-Jean-Baptiste as well as the Catholic Order of Foresters, a fraternal insurance society. (Courtesy Swanton Historical Society.)

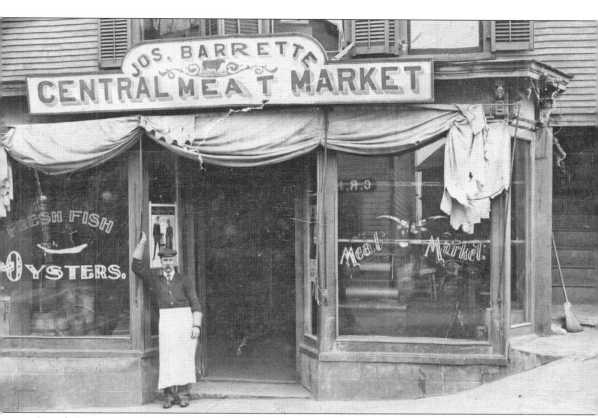

Joseph Barrette ran Central Meat Market in Swanton, Vermont, on Grist Mill Hill for 29 years after coming to the United States in 1880. He was born in Napierville, Québec. Joseph and his wife, Meranda Lussier, had a large French Canadian family with 12 children. (Courtesy Swanton Historical Society.)

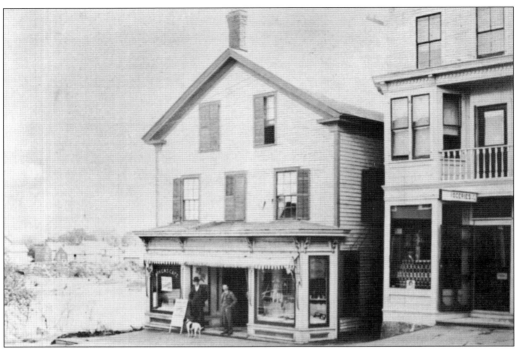

Euclide Trahan and Antoinette Rémillard, along with Joseph Trahan and Rose Rémillard, purchased the Swanton Bakery from L.M. and Victoria Papineau in 1919. It was located at 7 Merchants Row and bounded on the back by the Vermont Marble Company and to the south by Hector Barrette's Butcher Shop. The bakery was successful and had longevity, celebrating its 25th anniversary in 1944. Bread, marketed under the name Golden Crust, was the top seller but donuts were also popular (below). When their son Romeo was nine years old, Euclide and Antoinette sent him to a French Canadian boarding school in Montréal. (Both, courtesy Swanton Historical Society.)

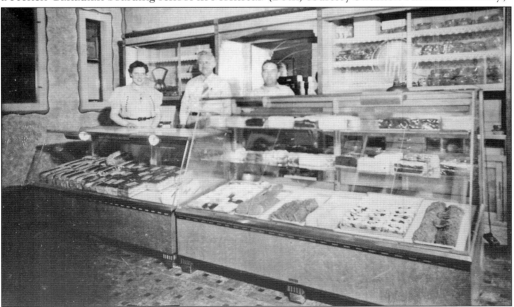

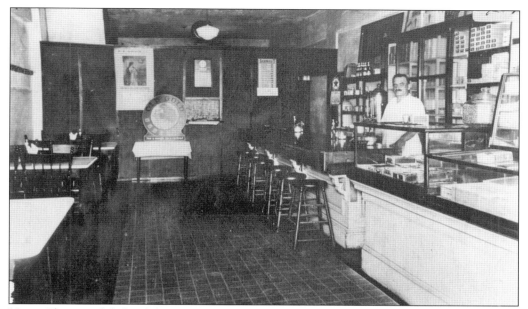

Henry Blais stands behind the counter of the Blais Restaurant in 1927. The sign in the back is for P.F. Giroux Furniture Company, a St. Albans, Vermont, business run by Philip Giroux, originally from St. Alexandre, Québec. French businesses often worked together as a tight-knit community. (Courtesy Swanton Historical Society.)

From left to right, R. Green, Fred Bourgeois, Leo Moreau, George Bourgeois, and Levi Bourgeois stand in front of the town clerk's office in Swanton, Vermont, around 1910. They were making repairs to the building and constructing a new jail. Levi and Fred were brothers born in Vermont of parents from Québec. (Courtesy Swanton Historical Society.)

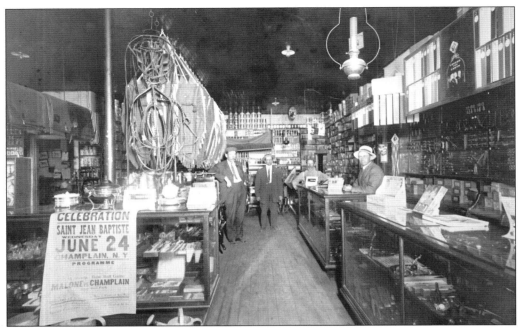

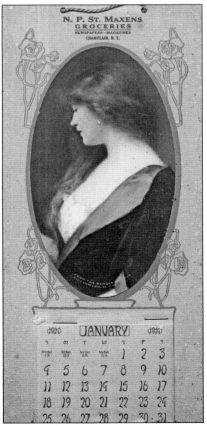

William Broder, William Paquette, Henry LaFontaine, and Robert Bestor are gathered inside William Broder's hardware store in Champlain, New York. Note the poster in the lower left corner announcing the celebration for Saint-Jean-Baptiste Day on Wednesday, June 24. One of the main advertised events is a baseball game between teams from Malone, New York, and Champlain. (Courtesy Samuel de Champlain History Center.)

Narcisse Ponchel St. Maxens was born on August 30, 1858, in Hermelinghen, France, and arrived in New York as a young man in 1875. He married Ida Jefferson (Geoffrion) and lived on Main Street in Champlain. He served as village clerk from 1891 to 1930. He reopened the local Catholic school in 1877 and taught there, mainly in French, until it closed in 1904. This 1914 calendar advertises his grocery store. (Courtesy Samuel de Champlain History Center.)

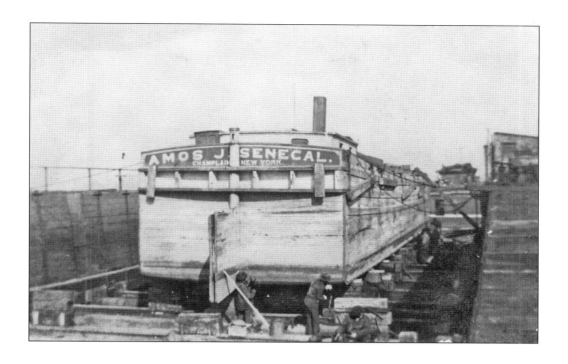

Above, the *Amos J. Senecal* canalboat from Champlain, New York, docks at an unknown location. Many barges, canalboats, and private boats that traversed up and down Lake Champlain were owned or operated by Franco-American families. Goods were transported from Québec all the way to New York City and many stops in between. Louise Lafountain Chevalier, also of Champlain, remembers traveling the Québec–New York route on her father's boat and missing several months of school each year because of the long canalboat season. Sénécal's license is displayed below. (Above, courtesy Samuel de Champlain History Center; below, courtesy Janet Carey.)

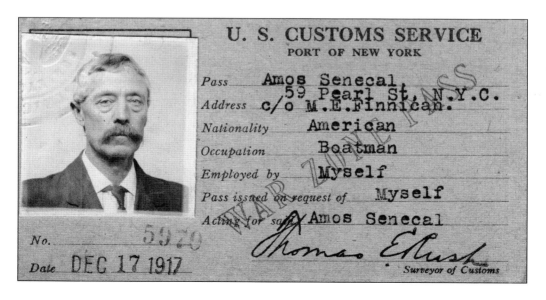

PURE COLD-PRESSED
Castor Oil.

DOSE.—For adults, one to two tablespoonfuls; children ten years old, two to four teaspoonfuls; five years old, one to two teaspoonfuls.

H. W. FALCON, Pharmacie Francaise,
15 Main St., CHAMPLAIN, N. Y.

The border town of Champlain, New York, was heavily populated with French Canadians. The label above from Falcon's Drugstore proudly notes that it was a "Pharmacie Francaise." Falcon's was located on Main Street in Champlain. Below, William or Henry Falcon stands in front of a counter inside the store filled with pharmacy bottles and other sundry items. Henry opened the store in 1911, and his son William managed it after Henry's death in 1932. It was frequented for the variety of items it contained, including the village's first soda fountain. (Above, courtesy Kimberly Lamay Licursi; below, courtesy Samuel de Champlain History Center.)

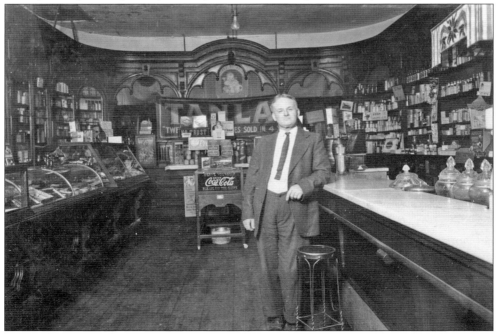

Arsene Tremblay (above) was born in Champlain on May 18, 1894. He became a prominent businessman and community leader. With his son, Leon, he owned and operated Tremblay Chevrolet Sales & Service from 1925 to 1960. The business continued until 1967. It was one of the largest auto dealerships north of Albany. The building now houses the offices of the Village of Champlain. Arsene Tremblay was mayor of the village of Champlain from 1926 to 1943 and again from 1947 to 1951. As a longtime supporter of St. Mary's Church, he also served as a church trustee. He died on October 13, 1960. (Above, courtesy Deane Trembley; below, courtesy Samuel de Champlain History Center.)

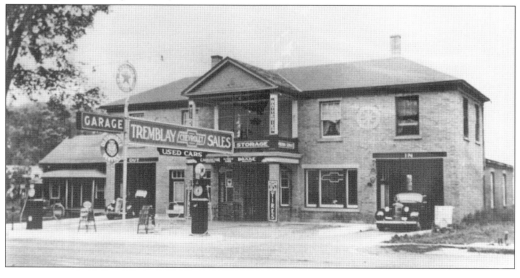

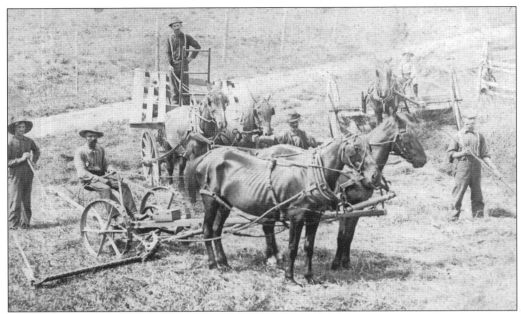

This undated photograph was probably taken on the DuBois farm on DuBois Road in Perry's Mills (Champlain), New York. The farmer on the far right with the pitchfork is Napoleon DuBois. Many French Canadian farmers eked out a living on small subsistence farms in rural areas. The poor condition of the horses in this picture suggests the hardships that farmers faced. (Courtesy William DuBois.)

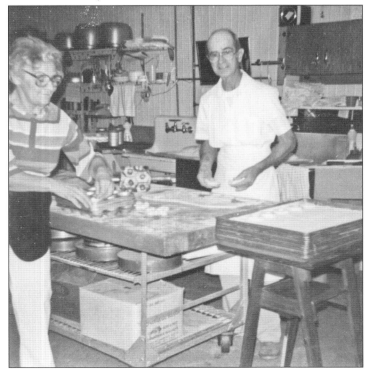

Pictured here are Leo and Edna Favreau Anctil, who operated Anctil's Bakery in Champlain, New York, for 40 years. Leo Anctil apprenticed with another baker in Champlain before opening Anctil's. In this photograph, they are shown making their famous donuts. Locals still salivate at the thought of Edna's donuts. (Courtesy John Anctil.)

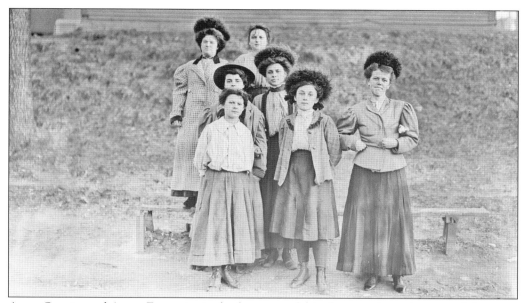

Anna Grenier and Agnes Fountain, in the front row of this photograph, are just two of the many women and child employees at the Chace Cotton Mills in Burlington, Vermont. Many French immigrant families found it necessary for most members to work to survive. Women and children were sought after as employees because they required less pay and were often more compliant than their male counterparts. (Courtesy Library of Congress.)

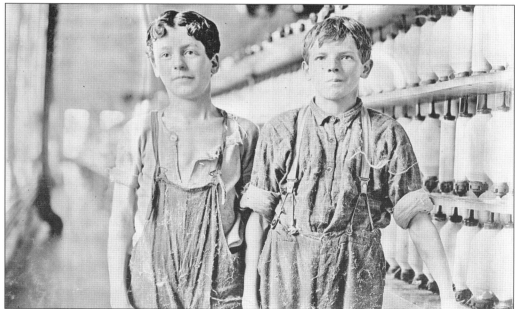

Leopold Daigneau and Arsene Lussier, back-roping boys, work in the mule spinning room at the Chace Cotton Mill in Burlington in 1909. French Canadian immigrants to Vermont often sought work in the huge cotton mills that dotted the area. In this respect, Franco-Americans played a significant role in the industrial expansion of New England in the last half of the 19th century. (Courtesy Library of Congress.)

Edgar Chiott was known as "Mr. Champlain" for his long association with Lake Champlain and many years in the boat business he took over from his father, Henry. Some of his wares are presented in this image. Chiott (Chaillot) was also the lighthouse keeper for 30 years. Both his father's and mother's families came to Vermont early in the 19th century from Québec. (Courtesy University of Vermont Special Collections.)

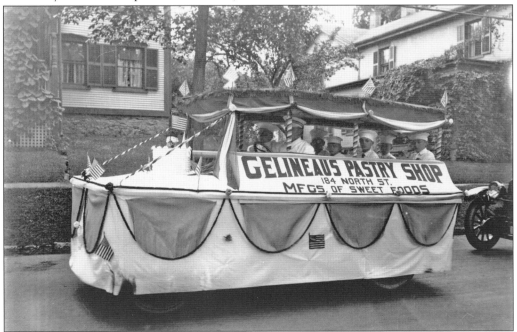

A parade float crafted by Gélineau's Pastry Shop displays bakers and a cake in this undated photograph. Gélineau's was a fixture on North Street in Burlington for many years. Herméngilde Gélineau established the shop in 1914, and his son Raymond and grandsons George and Ernest followed him in the business. Herméngilde, or Hermand, emigrated from St. Brigide, Québec, in 1893. (Courtesy University of Vermont Special Collections.)

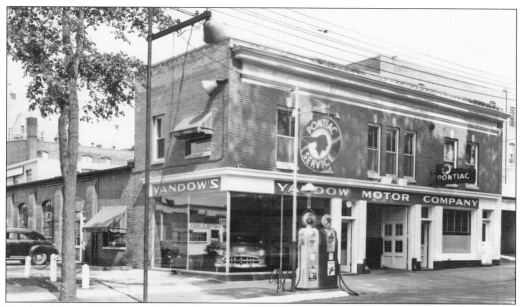

Yandow Motor Company was founded by brothers Harry and Harvey Yandow as More Mileage Tire Shop in 1921. They added a Pontiac dealership in the 1930s. The Yandow brothers' paternal grandparents were early settlers in Vermont from Québec in the 1840s and 1850s. Yandow comes from the French Guindon. (Courtesy University of Vermont Special Collections.)

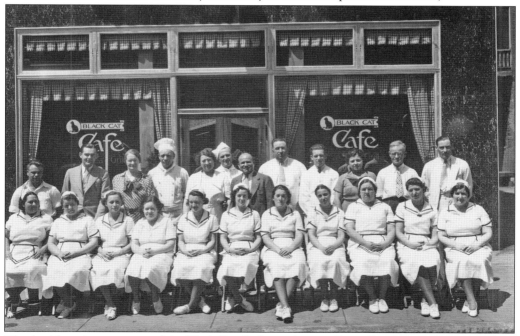

Charles Chantis, proprietor of the Black Cat Café, was born in Paris, France, in 1882 and became a naturalized citizen in 1904. He owned the café in Burlington, Vermont, for over 30 years. Many of the workers pictured here are likely French Canadians. (Courtesy University of Vermont Special Collections.)

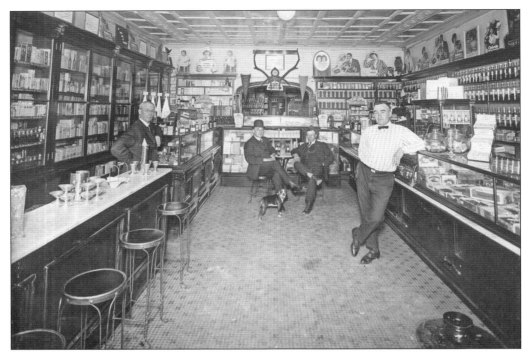

This photograph captures the interior of Turner's Drugstore on College Street in Burlington, Vermont, around the early 1920s. Louis Napoleon Turner (Letourneux), whose grandfather was born in Montréal, started working in a drugstore at age 14 in Keeseville, New York, and came from a family of druggists. (Courtesy John Fisher.)

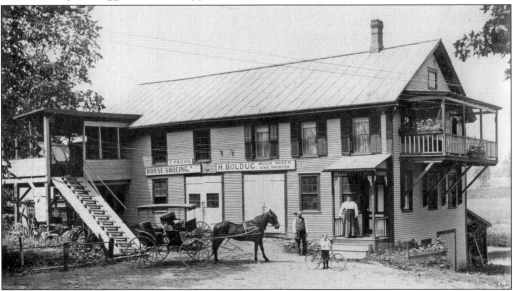

Henry Bolduc and Frederick Provo were both of Canadian origin, Henry by birth and Frederick through at least his father. They operated their blacksmith and wheelwright business out of this building in Rutland, Vermont, in 1912. According to the 1910 federal census, it appears that both families lived and worked at this location. (Courtesy Rutland Historical Society.)

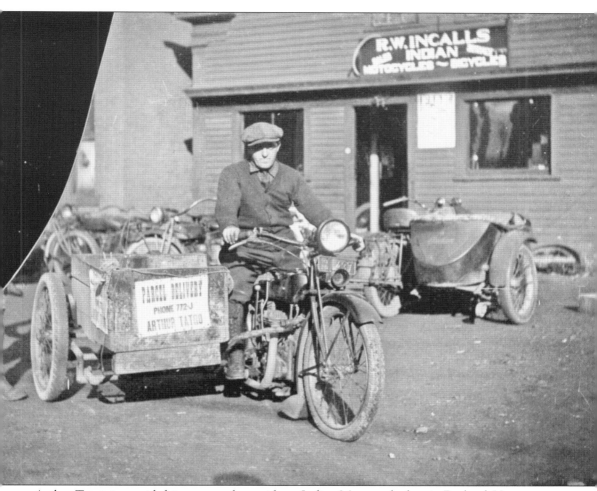

Arthur Tatro sits astride his motorcycle outside an Indian Motorcycle shop in Rutland, Vermont. His last name is an Anglicized version of the French Tetrault or Tetreault. Many French-sounding names were changed by families who were trying to assimilate into American society. Other names were changed during the immigration process or by census takers who used phonetic spellings. (Courtesy Rutland Historical Society.)

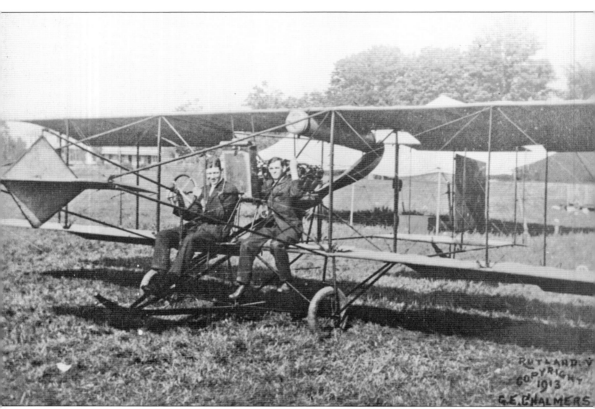

Wilfred Frenier (right) is pictured on an early airplane with George Schmitt in 1913. Wilfred had served as Schmitt's mechanic in Schmitt's attempt to be the first to fly in Vermont in 1910. He also built the Frenier Automobile Garage on Cleveland Avenue in Rutland in 1905. He was a pallbearer at Schmitt's funeral after his plane crashed while performing aerobatics at the Rutland Fair. (Courtesy Rutland Historical Society.)

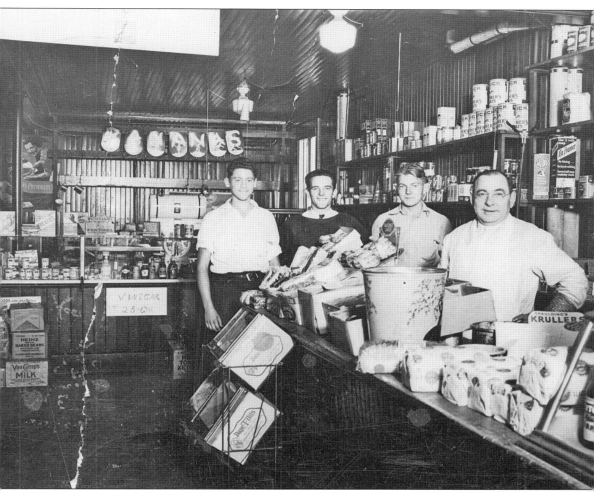

Ernest Laporte and George Laporte (left) stand inside Laporte's grocery on Clifton Street in Waterford, New York. George and his wife, Clara, lived over the store. George had worked as a winder in one of Waterford's wool mills at 19 years of age before becoming a grocer. (Courtesy Waterford Historical Museum and Cultural Center.)

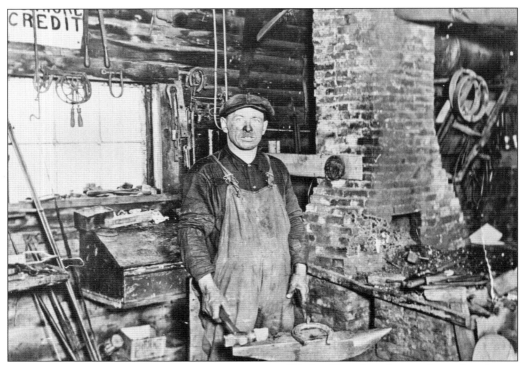

Eliodor Gagné works on a horseshoe in this photograph from the early 1930s. His father was a farmer in Roxton Falls, Québec, and Eliodor was the eldest of 14 children. In 1930, he came to Highgate Center, Vermont, where he established his blacksmith shop. This photograph originally appeared in *Look* magazine as an illustration for an article on the difficulties people faced during the Depression. (Courtesy Gabriel Gagné.)

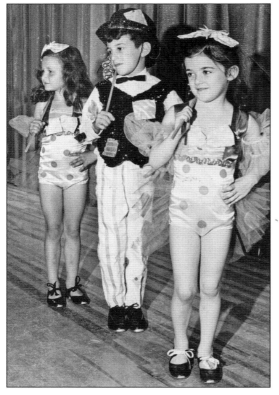

The Langlois School of Dance was founded in 1950 by Patricia Langlois-Racine. Julie and Michael Racine, the owner's children, appear in this late 1960s photograph. Dance and music were both important aspects of French Canadian life, and the *veillé*, or house party, was a community staple. It was also called a "kitchen dance" because of the dancing that was often the focus of the festivities. (Courtesy Barbara Racine.)

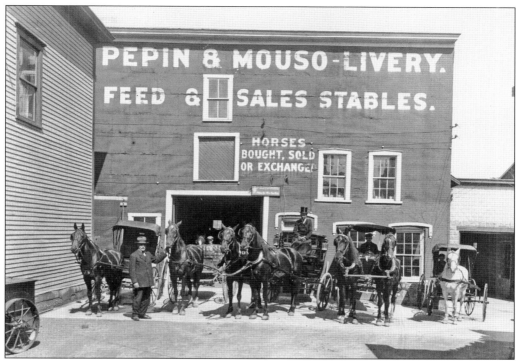

Louis Pépin and Edward Mouso (Mousseau) had a livery, stable, and garage operation at 18 Margaret Street in Plattsburgh in the early 20th century. The livery business expanded into the automotive and garage business around 1912 as automobiles became more prevalent. (Courtesy Clinton County Historical Association.)

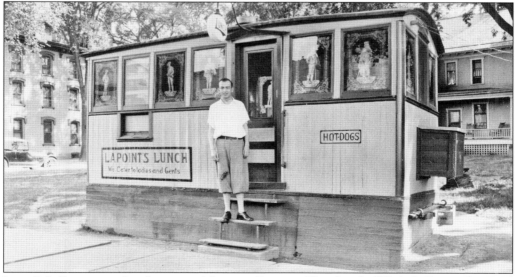

Leon J. LaPoint ran a lunch stop on Margaret Street in Plattsburgh. While LaPoint advertised his hot dogs, one of the most iconic items of French Canadian cuisine is *tourtière*, or meat pie, which is typically served on Christmas and Easter. It is made with minced pork, veal, or beef. (Courtesy Clinton County Historical Association.)

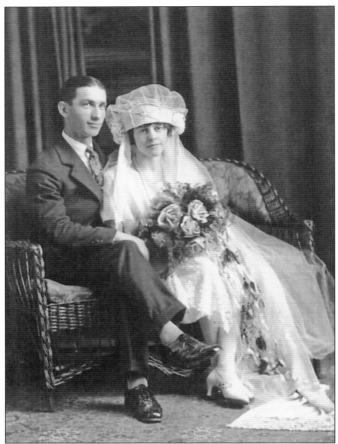

Joseph Alphonse Delphis Béchard married Marie Corinne Bernadette Lareau on June 10, 1925, at St. Romain Church in Hemmingford, Québec. She was from Lacolle, Québec, and he was from Champlain (Coopersville). Alphonse Béchard owned the general store bearing his name in Champlain (below). He was a descendent of Moise Béchard, who had brought his family to the United States in 1888. Alphonse was also a bootlegger during Prohibition. He took full advantage of the proximity of the Champlain hamlet of Coopersville to the Canadian border. (Left, courtesy June Béchard Trombly; below, courtesy Clifton Gamache.)

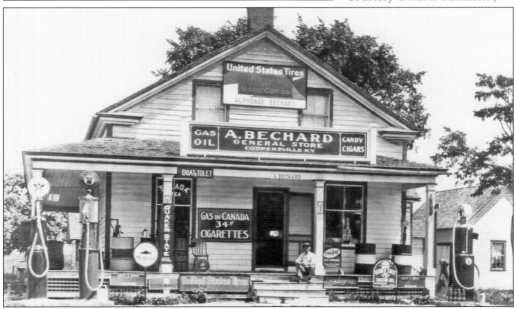

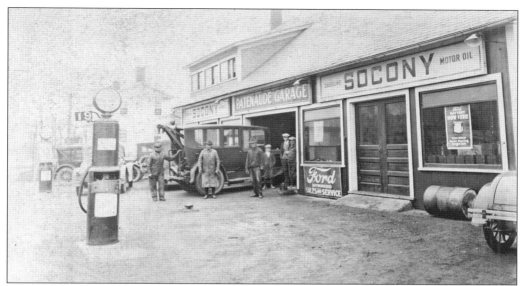

Peter and Hubert Patenaude were the proprietors at Patenaude Garage and Ford Dealership in Chazy, New York. This photograph, taken around 1928, shows the front of their establishment on Route 9. Their advertising noted that their "skilled and experienced mechanics enables us to serve you promptly and with a measure of satisfaction unsurpassed in the North Country." The site is currently home to Riley Ford. (Courtesy Town of Chazy Historian.)

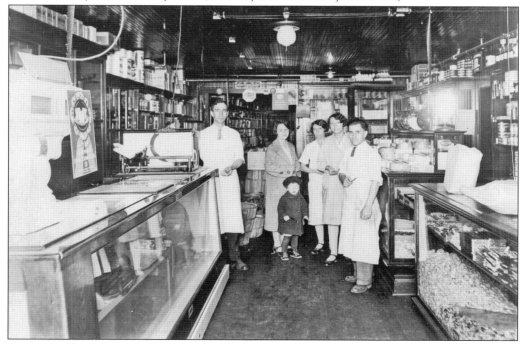

J.A. Ferland was born in St. Armand, Québec, in 1891 and came to the United States with his parents as one of 13 children in 1903. He spoke both English and French as an operator of Ferland's Market in St. Albans, Vermont. Ferland may have been a variation of Ferlin, a French name meaning "small weight." (Courtesy St. Albans Historical Museum.)

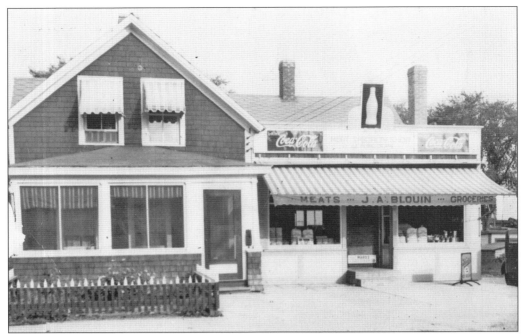

Joseph A. Blouin opened Blouin's Specialty Meat Shop in St. Albans in 1937. He learned the meat cutting trade from another Frenchman, Joe Lemaire, and worked at Ferland Market before opening his own. Blouin later expanded to shops in Richford and Swanton, Vermont. (Courtesy St. Alban's Historical Museum.)

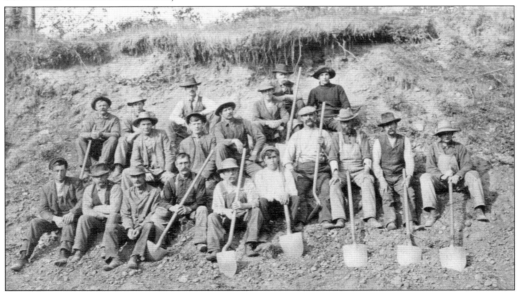

Quarry workers rest with their shovels in this undated photograph from Isle La Motte, Vermont. Those identified include Henry Parker, Wille Early, John Doolin, George Henry Pearo (Perreault), Andrew Holcomb, Stanley Fleury, Jim Gilbare, Allen Buchannan, Mahlon Gadbois, Nelson Jarvis, Peter Vanslett, Archie Vanslett, Seneca Pike, Albert Parker, Ben Duba, Peal Pearo, William Pearo, and Joe Pearo. At least eight are of French descent. (Courtesy Isle La Motte Historical Society.)

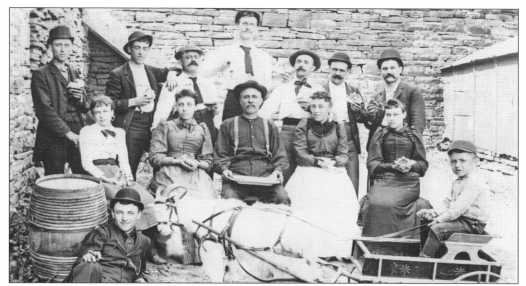

The Stephen (or Steven) Boulé family is seen in the yard of their home in Keeseville, New York, where they had a blacksmith and wagon-making shop. As tradesmen, they would have had an easier life than many French Canadian immigrants. Surrounded by his wife, daughters, and sons, Stephen Boulé is in the center of this photograph. (Courtesy Special Collections, Feinberg Library, SUNY College at Plattsburgh.)

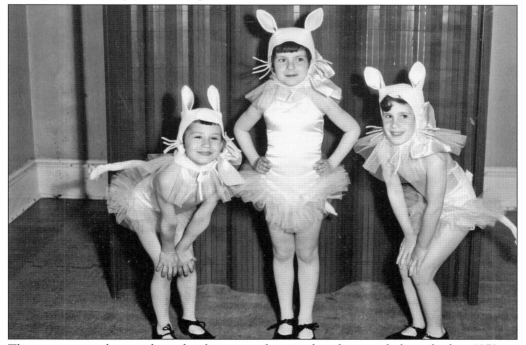

Three young tap dancers dressed as kittens perform in this photograph from the late 1950s or early 1960s. From left to right are Karen Sousie, Mary Jane Meunier, and Susan Ploof. They were students at the Lorette Sousie School of Dance on North Avenue in Burlington. (Courtesy University of Vermont Special Collections.)

Farmer Francis Gilbare (Guilbert) handles a team of horses outside the old stone schoolhouse in Isle La Motte. Gilbare's father, Thomas, was born in Vermont, but several of his brothers and sisters were born in Québec, as the family moved back and forth across the border. Thomas Gilbare served in the Civil War in Company K of Vermont's 6th Regiment. (Courtesy Isle La Motte Historical Society.)

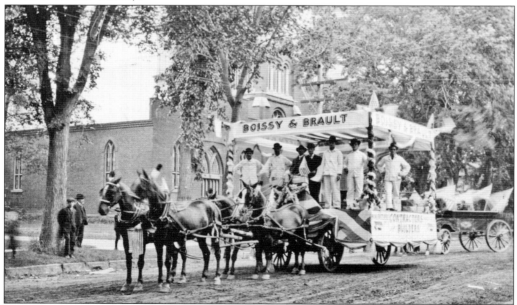

The Boissy & Brault float in a 1907 parade in front of St. Peter's Church in Plattsburgh. A Franco-American guide written in 1925 states that Francois Alfred Brault was an entrepreneur who started a contracting and building business with John B. Boissey in 1903. They built École St. Pierre in 1906. (Courtesy Lynne Kelley.)

Four

WINOOSKI

Winooski, Vermont, is a city with an enduring French Canadian legacy. For most of the 20th century, if one lived in Winooski, there was a high probability that one was French. Winooski is also one of the few places that still embraces its Franco-American heritage with an annual celebration coinciding with Saint-Jean-Baptiste Day on June 24. Visitors can watch traditional dancing, hear traditional music, and taste French Canadian cuisine. Residents gather to keep French and French Canadian culture alive. The French gained a significant presence in Winooski in the early 19th century, and as early as 1839, a French-language newspaper catering to the settlers, the *Patriote Canadien*, was published in nearby Burlington. In the 1850s and 1860s, the number of French grew dramatically as discontent in Québec rose and the burgeoning textile mills in Winooski offered employment. The city became the first large manufacturing center south of the border in Vermont.

By the late 19th century, the French permeated every aspect of this Yankee mill village. They were lawyers, farmers, doctors, undertakers, grocers, and furniture makers. The diversity of the French population allowed them to be self-sufficient and cohesive in a way that was not possible in most other places where Franco-Americans had settled. They could rely on one another for almost everything they needed. This sense of community is evident in the many French social and mutual benefit organizations that thrived in Winooski. The close-knit community was successfully able to keep the French culture and language alive. The vibrancy of the French heritage of Winooski is perfectly embodied in the steeples of St. Francis Xavier Church on St. Peter Street. French Canadian Catholics built an impressive convent and church in 1868 and 1870. The church serves as a focal point not only for the French but for all of Chittenden County because of its unique beauty and bold presence in the skyline. The twin spires atop the church rise high in the air and are a constant reminder of the Franco-Americans who helped build Winooski.

FRANÇOIS LECLAIRE,
né à St-Jean-Baptiste de Rouville en 1818; décédé à Winooski, Vt., en 1889; homme dévoué envers l'Eglise et envers ses compatriotes.

R. I. P.

Francis LeClair was born in St. Jean Baptiste de Rouville, Québec, in 1818 and came to Winooski in 1828. One of Winooski's most prominent citizens, he owned a successful brickyard and used his wealth to subsidize the construction of brick homes for low- and moderate-income residents along with St. Francis Xavier Church. LeClair Street and LeClair Avenue in Winooski both bear his name. (Courtesy Joseph Perron.)

Designed by Joseph Michaud of Québec, St. Francis Xavier Church was built to serve more than 850 French-speaking Catholics in Winooski Falls, Colchester, and Essex. Francis LeClair provided wood and brick, and parishioners undertook much of the construction. In 1871, the first mass was held in the unfinished church. In 1883, the copper-clad Gothic spires and belfries were added, with metalwork by Joseph Lanoue of Burlington. (Courtesy Joseph Perron.)

In 1868, newly ordained Rev. Jean Frédéric Audet from St. Hyacinthe, Québec, was assigned to a new Catholic parish that would serve Winooski, Colchester, and Essex. Bishop Louis deGoesbriand had divided St. Joseph's Parish in Burlington because of the ever-growing community of French Catholics north of the Winooski River. Father Audet served this new parish, St. Francis Xavier, for 49 years. (Courtesy Joseph Perron.)

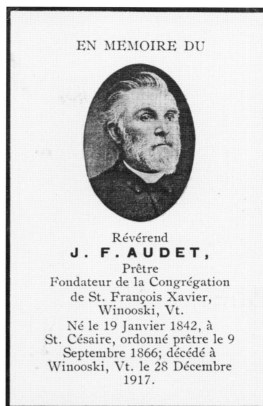

EN MEMOIRE DU

Révérend
J. F. AUDET,
Prêtre
Fondateur de la Congrégation de St. François Xavier, Winooski, Vt.
Né le 19 Janvier 1842, à St. Césaire, ordonné prêtre le 9 Septembre 1866; décédé à Winooski, Vt. le 28 Décembre 1917.

The rectory for St. Francis Xavier Church demonstrates the French Canadian influence on architecture. Joseph Michaud, a French Canadian architect from Montréal, incorporated casement windows and roof dormers that were much more typical in Québec. The building also has a rooster weather vane, popular in Normandy and Brittany, France, and symbolic of St. Peter's denial. The rooster is one of the national symbols of France. (Courtesy Vermont State Archives and Records Administration.)

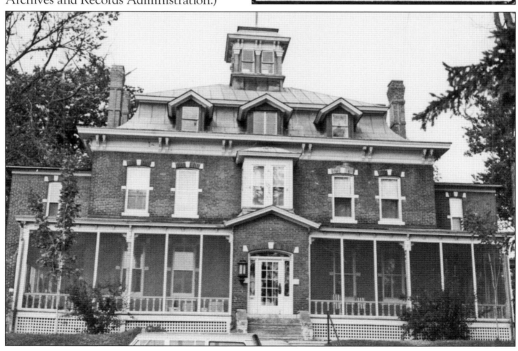

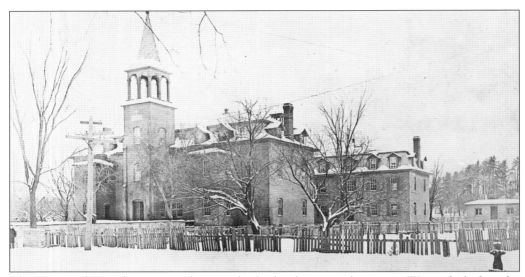

The Sisters of Providence started a parochial school in rented space in Winooski before the construction of St. Louis Convent on West Spring Street. By 1869, the convent served as both a home for the sisters and a school. This photograph depicts the convent around 1908. Although most of those who attended St. Louis School spoke French, Bishop Louis deGoesbriand insisted the school be bilingual. (Courtesy Joseph Perron.)

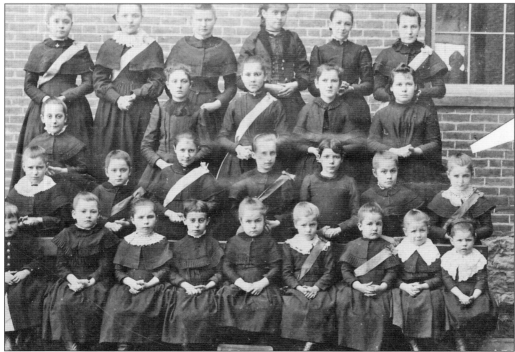

St. Louis Convent was the successor to the first parochial school started by the Sisters of Providence in 1863. The bilingual school served French Canadians and was an important instrument in the assimilation process. This 1891 photograph is titled *Convent Boarders*, which likely refers to children who lived at the convent while attending school. (Courtesy Winooski Historical Society.)

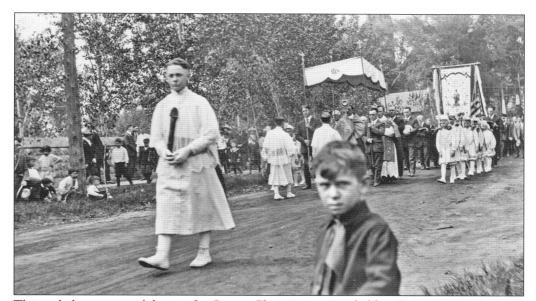

This real-photo postcard depicts the Corpus Christi procession held on June 3, 1923. The Feast of Corpus Christi mass is often followed by a procession with the Eucharistic host. The first flag in the parade in this image is for the Société St. Pierre, a historically minded organization that sought to preserve the Acadian culture and language. (Courtesy Annette Picher.)

The *Caisse Infantile* of the Union Saint-Jean-Baptiste is in front of the St. Louis Convent in Winooski, Vermont, in June 1928. The Caisse Infantile was typically made up of the children of adult initiated members of the group. Those identified include Rita Villemaire, Anita DeVarney, Cecile Dion, Rita Boucher, Jeannette Fregeau, Claire Bouchard, Aletha Gadue, Aline Gravel, Madeleine Picher, Leona Desautels, and Constance Crowley. (Courtesy Winooski Historical Society.)

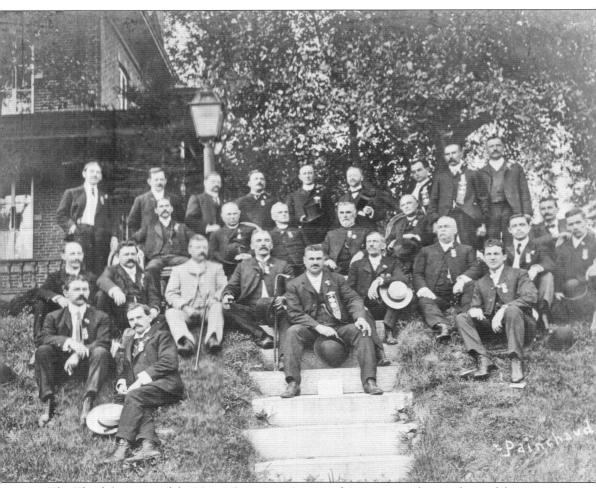

The Third Congress of the Union Saint-Jean-Baptiste d'Amérique gathers in front of the rectory of St. Francis Xavier parish in 1903. Those identified include, from left to right, (top row) Dr. Bachand of St. Johnsbury, Vermont; Jean-Baptiste Brazeau of Pawtucket, Rhode Island; Dr. Boucher and P. Boucher of Woonsocket, Rhode Island; Félix Gastineau of Southbridge, Massachusetts; J. Adélard Caron of Woonsocket; J.-E. Dupré of Brockton, Massachusetts; and Ulric Leclair and Emile Blais of Winooski; (middle row) Honorable Archambault (lieutenant governor of Rhode Island); Rev. Michel D. Charbonneau of Keeseville, New York; Rev. F.X. Chagnon of Champlain, New York; Rev. Jean-Frédéric Audet of Winooski; and Rev. Antoine P. Clermont of Newport, Vermont; (bottom row) Messrs. Dubois and Brochu of Worcester, Massachusetts; L.-P. Aubin and A. Choquette of Newport; Joseph Goddu of Holyoke, Massachusetts; J.-A. Lasalle of Woonsocket; A.-J. Lachance of St. Johnsbury; and Dr. Coutu of Burlington; Ed Laflamme of the *Woonsocket Tribune;* and Jules Guerin of *La Presse* in Montréal. (Courtesy Winooski Historical Society.)

There were many societies representing the large French population in Winooski. A 1903 celebration in Burlington noted three delegations of French from the city, including the Société St. Pierre with 320 members, the Club Champlain with 140 men, and the Conseil St. Laurent Union Saint-Jean-Baptiste with 80 men. This pin would have been worn by members of the Union Saint-Jean-Baptiste. (Courtesy Joseph Perron.)

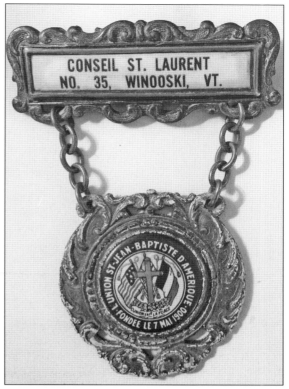

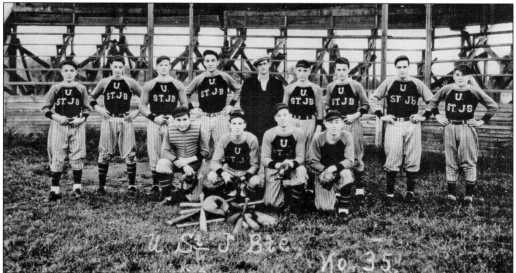

The baseball team of the Conseil St. Laurent Union Saint-Jean-Baptiste d'Amérique is pictured at Hawthorne Field in Winooski between 1935 and 1938. From left to right are (first row) Leo Quenneville, Armand Roy, Adolphe Richard, and Arthur Miller; (second row) Paul Lesage, Roland St. Pierre, Clement "Chick" Alarie, P. Goudreau, Theodule Tremblay (coach), Bernard Poirier, Armand "Bing" Miller, Paul Richard, and Armand "Jimmy" Myers. (Courtesy Winooski Historical Society.)

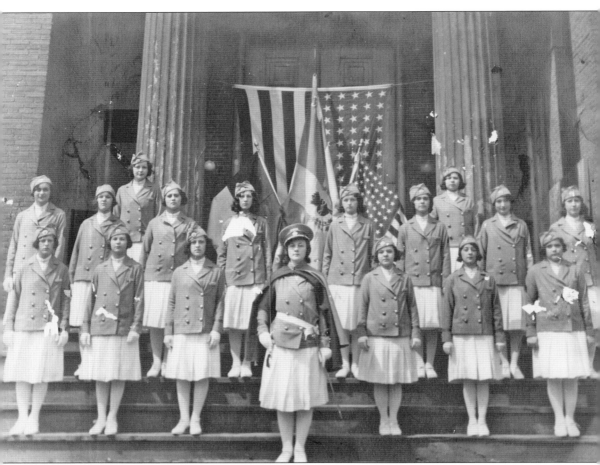

The Sainte-Thérèse Drill Team poses on the steps of old Winooski City Hall on West Allen Street in 1932. The drill team was a component of the Union Saint-Jean-Baptiste d'Amérique. In that same year, the drill team performed dancing and marching routines during the installation of officers for five different Union Saint-Jean-Baptiste organizations. The young women are standing in front of the French flag, Carillon flag, and American flag. On the steps are (first row) Capt. Laurette Poirier (later Jasmin); and, from left to right, (second row) Ida-Mae St-Pierre, Agnes Lamothe, Edna St-Pierre (later Hatin), Marie-Marthe Rocheleau (later Cole), Simonne Morin (later Lavallée), and Desneiges Barsalou (later Garcia); (third row) Anita Carrière (later Atkins), Rita Bouffard (later Vartuli), Françoise Bleu (later Tremblay), Lucille Babeu (later Andrew), Hélène Jasmin (later Baillargeon), Florence Dupuis (later Allard), Anita Mongeon (later Quill), and Béatrice Jasmin (later Barre); (fourth row) Alice Mongeon (later Frenette) and Yolande Rocheleau (later Rouselle). (Courtesy Winooski Historical Society.)

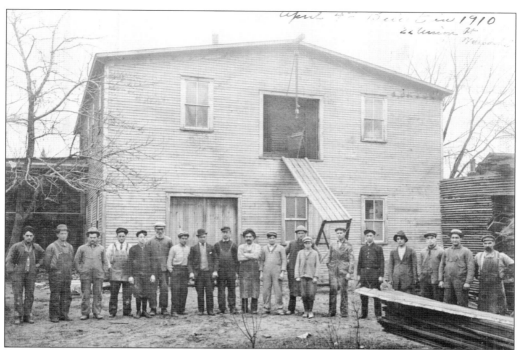

Workers stand outside the original factory where Eugene A. Richard, a native of Cap Santé, Québec, and his brother Omer started the Richard Manufacturing Company behind their home on Union Street in Winooski (above). The building was constructed in 1910, and this photograph is from around that time. The brothers manufactured screen doors, medicine and sanitary cabinets, school desks, caskets, and custom, ornately carved furniture and radio cabinets. The company would be renamed the Vermont Furniture Company around 1933. Under the new name, the company used local wood to produce hard rock maple furniture until the factory burned in 1973. This chair (at right) was produced by the Vermont Furniture Company in the 1940s. (Both, courtesy Winooski Historical Society.)

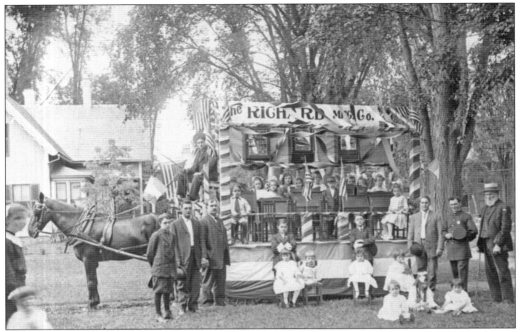

This patriotic Fourth of July parade float on Main Street at the corner of Union Street was crafted by the Richard Manufacturing Company. The float displays the company's wares, including medicine cabinets, chairs, and slant-front desks, as well as several American flags. While the French held closely to their traditions, they were also proud Americans. (Courtesy University of Vermont Special Collections.)

Lewis Hine, a celebrated photographer who documented the plight of young workers on film, captured this image of Albert Lavalle on his first day of work at the American Woolen Company in Winooski in 1910. Lavalle, just 14 years old, would have joined many other French Canadian children in Winooski doing difficult and sometimes dangerous work for little pay. (Courtesy Library of Congress.)

Arthur LaVigne entered the undertaking profession in 1888 in the old Winooski Block. LaVigne then opened the funeral parlor shown here on East Allen Street and later moved to Main Street. His son, grandson, and great-grandson followed him in the family business, and the current owner still operates under the LaVigne name. The hearse pictured here was manufactured in Winooski by the Richard Manufacturing Company. (Courtesy Winooski Historical Society.)

Regis Dufresne migrated with his family from Sainte-Sabine, Québec, to Massachusetts and then to Winooski in 1905. His wife, Dorilda Couture, was originally from Sherington, Québec. Dufresne opened this service station on Main Street in the 1930s. The business was passed down through the generations to his grandson Raymond Dufresne. As with many French Canadians, faith was important to the Dufresne family, and Regis had three sisters and a daughter who were religious sisters. (Courtesy Winooski Historical Society.)

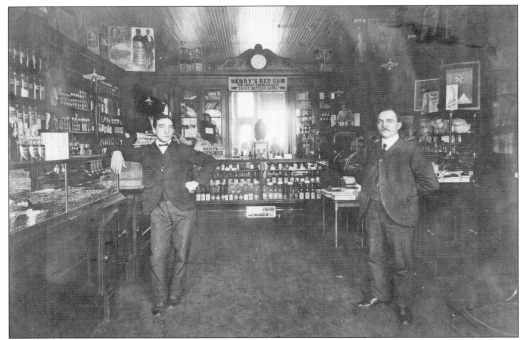

This image captures the interior of Marcotte Pharmacy on Main Street. It was founded by Seraphin and Louis Marcotte and located on a block with several other French-owned businesses. Anna Dufresne, Seraphin Marcotte's daughter, worked as a pharmacist there for several years and was reportedly Vermont's first female pharmacist. (Courtesy Winooski Historical Society.)

Arthur A. Bouffard was a deliveryman for the Hormidas J. Mercure Creamery in the 1920s. Both Bouffard and Mercure were members of the Union Saint-Jean-Baptiste. They provided year-round delivery of dairy products to families. (Courtesy Winooski Historical Society.)

NIGHT OF REST MOTEL

1 Mile North of Burlington

Routes 2 & 7

Dial UN 4-4038

Nous parlons français

Leonard and Rolande Bissonnette owned and operated the Night of Rest Motel on Route 7 in Colchester, Vermont, for over 35 years. Their business card proudly notes, "Nous Parlons Francais" (We Speak French), which appealed to Québec visitors. Franco-Americans were a tight-knit group, and French-owned businesses operated in a distinct network with each other and within the French community. (Courtesy Joseph Perron.)

The Chévrier Block, listed in the Vermont registry of historic buildings, was noted as looking "completely in place on some narrow side street of Montréal." It was built in 1903 and housed a shoe and boot store downstairs, while the Chévrier family lived upstairs. Some of the defining French characteristics of this building include the oriel window and balcony, the elaborate cornice, and beige-tinted masonry. Emile Chévrier was born in Canada and immigrated at age 25 in 1897. Without English skills and with only two years of high school, he was successful in real estate and insurance among other ventures. His J.B.E. Chévrier Block is one of only two buildings in Winooski influenced by French Canadian architectural styles. In 1899, he helped create a French artisan guild. (Courtesy Assumption College.)

Along with Seraphin Marcotte's pharmacy on Main Street, Oliva Richard operated a French pharmacy on East Allen Street in the Winooski Block. Richard emigrated from Cap Santé, Québec, when he was just 10 years old and became a naturalized citizen in 1910. Newspaper accounts indicate he was a member of Club Rochambeau. Richard advertised his drugstore as La Canadienne Pharmacy on this bottle label from the 1920s. The aromatic syrup of rhubarb was an incredible 7.4 percent alcohol by volume. An infant dose was up to one teaspoon every two hours until the medicine had "operated" on the child's bowel complaints. The line in the center of the label allowed the prescription to be written in French. (Both, courtesy Joseph Perron.)

The Union Saint-Jean-Baptiste members were concerned with not only the financial but also the social and cultural welfare of French Canadians. Before 1931, they rented space in the Corporation Block with a public hall and stage for group events. They purchased the building in 1931 and used it for traveling shows, local performers, and community events. The poster (at right) for a traveling acting group from Montréal, La Troupe Franco-Canadienne, is from 1931. Winooskians in Club Champlain and Club Maisonneuve also presented French plays and musical entertainment, often in the French language (below). An 1890 article reports that the two-act melodrama presented by the Club Champlain, *The Pontifical Zouave* (a Zouave was a French army light infantryman), easily persuaded the audience "that Frenchmen are natural actors." Performances drew Franco-Americans from Burlington, St. Albans, and neighboring towns. (Both, courtesy Winooski Historical Society.)

Membres du Club Maisonneuve.

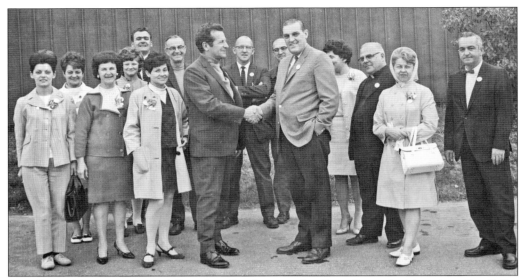

Jean Pierre Masson portrayed Séraphin Poudrier on the Canadian television show *Les Belles Histoires des Pays d'en Haut*, one of the longest-running radio and television dramas in Canadian history. It depicted a French community in 1880s Sainte-Adèle, Québec. Masson is shaking hands with Mayor Edmund DuPont (right) and Fr. George St. Onge (behind) on the centenary of St. Francis Xavier Parish in 1968. (Courtesy Louise Rocheleau.)

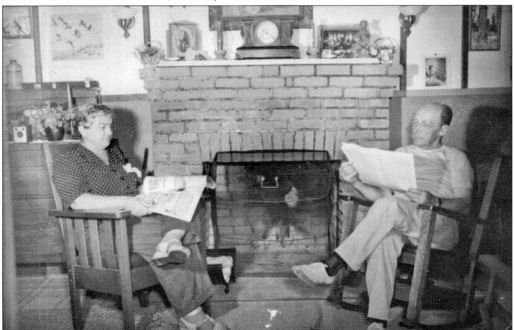

In this c. 1955 photograph, Corinne Duquette Poirier and her husband, Gaston, sit in their home on Weaver Street. Corinne was a well-known playwright who crafted many theatrical productions in French, including *Victime de Jalousie*, often to raise funds for French societies or St. Francis Xavier Church. Their only son, Jean "Bernard," died during aviation exercises in Florida and was the first World War II casualty from Winooski. (Courtesy Joseph Perron.)

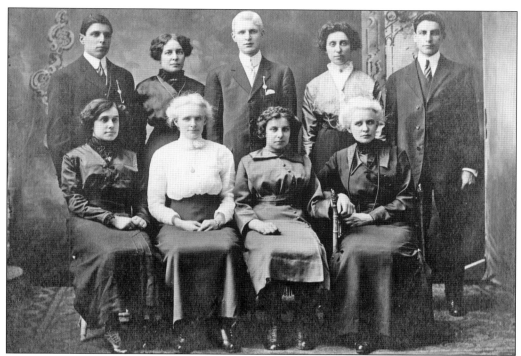

The nine children of the Lesage family are pictured around 1915. Three of the children suffered from albinism, as evidenced by their white hair and pigment-free eyes. From left to right are (first row) Odiana, Georgianna, Marie Anna, and Zelia; (second row) Arthur, Zepherina, Alfred, Aurore, and George. Alfred went on to have a family of 12 children and operated a grocery market on West Street. (Courtesy Joseph Perron.)

French Heritage Day began in 2015 to keep French culture alive in Winooski. The celebration coincides with the feast of Saint-Jean-Baptiste, patron saint of Québec, on June 24. The celebration dates back centuries and is a widely recognized holiday in Québec. The festival features live music, art, crafts, history, and food of French origin. Céline Racine Paquette of Champlain, New York, stands in front of the banner. (Courtesy Ginette Warner.)

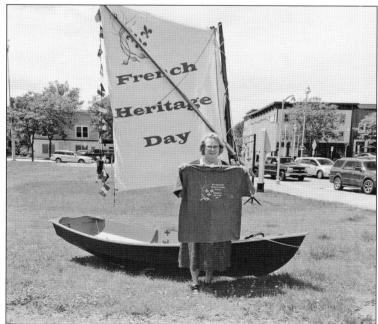

In 1932, the officers of the Cercle Dramatique Sainte-Cécile of the Union Saint-Jean-Baptiste sit in Hector Huard's photography studio for their portrait. From left to right are (seated) Florence Mongeon, Jeanne Picher, Agnes Hébert, and Blanche Lord; (standing) Laurent Villemaire, Maurice Paquette, Henri "Mike" Villemaire, and Edouard Matte. Not pictured is Corinne Poirier. (Courtesy Winooski Historical Society.)

Five

CULTURE

There are many behaviors and beliefs that French Canadians share as an ethnic community. Their religion, language, customs, values, music, history, building styles, and food have contributed to American culture because of their strong presence in the Champlain Valley. When French Canadians first began coming to the United States in large numbers in the mid-19th century, they felt pressure to assimilate, to adopt the ways of Yankee Protestants, or to integrate into Catholic churches dominated by the Irish. They were faced with the dilemma of speaking a foreign language and enrolling their children in local schools where students were taught different values. French Canadian immigrants, however, were successful in maintaining their culture while under great pressure to conform.

French Canadians began to push back almost immediately through the establishment of fraternal and social organizations designed to serve as a financial safety net, social network, and force for protecting the French language and customs. The two largest groups, the Union Saint-Jean-Baptiste and the Canado-America Club, were joined by a host of other regional and local organizations for men, women, and children. It is within these groups that French Canadians formed an insular community where French music, theater, language, celebrations, customs, and food were sheltered and treasured. The father's New Year's blessing, the celebration of Saint-Jean-Baptiste Day, family musical traditions and storytelling, strong faith communities, and the iconic tourtière or meat pie, among other foods, are all part of what the French brought to this country and fought hard to preserve.

Community leaders were successful in safeguarding many of these traditions, and some continue today, like the Christmas Eve *réveillon*, the maple sugarbush parties, and the loving words children still call their grandparents, *mémère* and *pépère*. On occasion, there is the family house party with the traditional fiddle and songs. Family gatherings are an important element of French Canadian culture, evidenced by the great number of incorporated and formalized family associations with annual reunions and newsletters.

Above, the Union Saint-Jean-Baptiste marches down Church Street in Champlain, New York. Ludger Duvernay formed the group in 1834 as a fraternal benefit and patriotic association to stimulate nationalist sentiment among the French in Canada and to encourage them to protect French Canadian culture. The group planned special events on June 24 in honor of patron St. John the Baptist. The Union Saint-Jean-Baptiste was officially formed in the United States in 1900 to promote the social and moral welfare of its members and to assist the sick, disabled, and dependents of deceased members. Below, a Saint-Jean-Baptiste parade travels by the Trepanier and LaFountain grocery store in Champlain on June 24, 1913. The float in front is sponsored by harness maker F.X. Jodoin. The wagon behind is decorated with "Champlain" pennants. (Both, courtesy Samuel de Champlain History Center.)

The pin below, featuring both the American and French flags, is from the Champlain Council of the Union Saint-Jean-Baptiste. The Union Saint-Jean-Baptiste originated in Montréal, Québec, as an attempt to preserve French national rights around the time of the Papineau Rebellion. The organization spread to the United States in various forms in the 1850s. The pin at right is from one of the earlier groups. By 1891, there were 252 similar societies in America. (Both, courtesy Joseph Perron.)

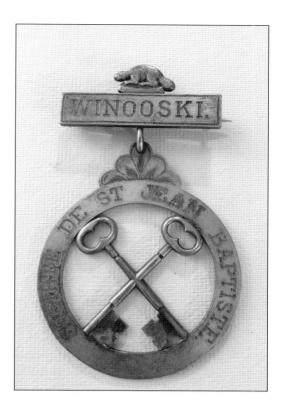

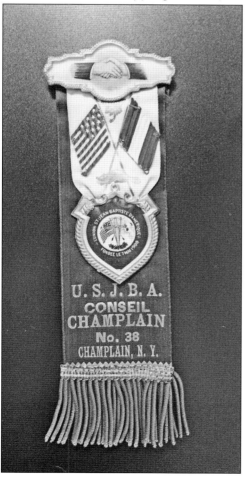

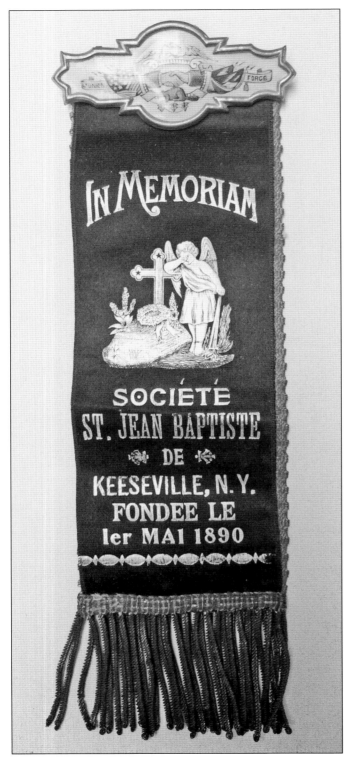

A member of the Keeseville, New York, branch of Société Saint-Jean-Baptiste, founded in May 1890, would have worn this "In Memoriam" pin in memory of a deceased member. (Courtesy Anderson Falls Historical Society.)

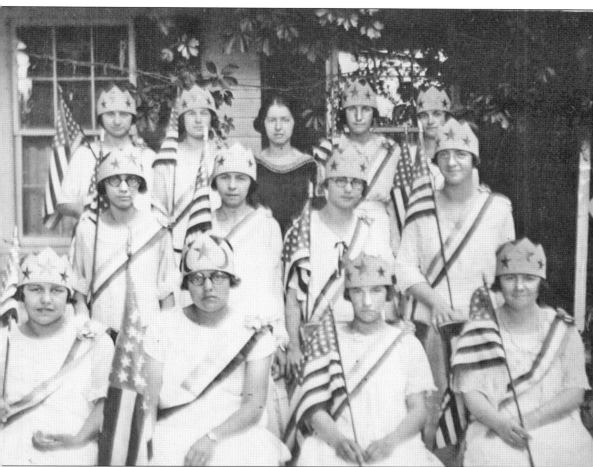

This group of patriotic women was part of the Union Saint-Jean-Baptiste *Équipe d'initiation du Conseil Charbonneau*, or initiation team of the Charbonneau Council in Keeseville, New York. The photograph, probably from the 1920s, attests to the devotion the French had to their new country. The women, proudly carrying American flags and wearing red, white, and blue sashes, are, from left to right, (first row) Hélène Desroches, Blanche Martin, Hélène Dionne, and Rachel Galarneau; (second row) Béatrice Galarneau, Irène Mitchell, Eugénia Picotte, and Blanche Tellier; (third row) Mérilda Bisaillon, Priscilla Gladu, Mildred Laroche, Mildred Bisaillon, and Agnes Martin. (Courtesy Assumption College.)

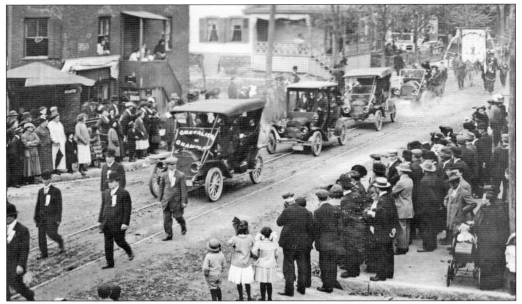

The Chevaliers de Champlain banner adorns a car along a parade route in Winooski, Vermont. The group was a men's fraternal and benefit society formed in Burlington in 1911. Within one year, it had well over 200 members. A Winooski council was organized in 1912. The group was likely disbanded by 1917. The organization behind the Chevaliers appears to be the Union Saint-Jean-Baptiste. (Courtesy Joseph Perron.)

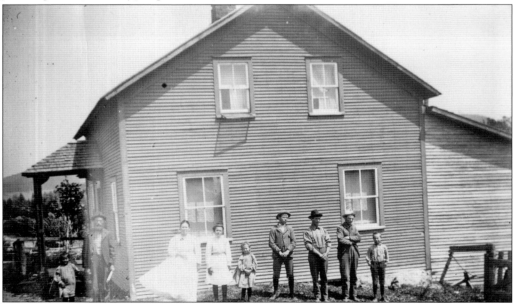

French immigrants typically lived in distinct neighborhoods where they could speak their language freely and interact with others sharing their faith and habits. The Landry house, on Montcalm Street in the French Quarter in Plattsburgh, New York, was no exception. The 1921 city directory lists Frank Landry and his two sons, Raymond and Alfred, as living in the house. (Courtesy Clinton County Historical Association.)

A family sits outside the Henry Sanschagrin house in Champlain, New York, in this undated photograph. The name *Sanschagrin* roughly translates as "without grief" and has been Anglicized as Sawyer. The French Canadian neighborhood in Champlain was known as the French Village and was located in the northern part of town. (Courtesy Samuel de Champlain History Center.)

The Garand homestead in Perry's Mills (Champlain), New York, has dormer windows that were typical of houses in Québec. Other features of French Canadian homes that could be seen in New York and Vermont include flared and/or steep rooflines and brightly colored roofing materials. Francois Xavier Garand is seated, and Emma Garand Béchard is to the left of him. (Courtesy Jane Béchard West.)

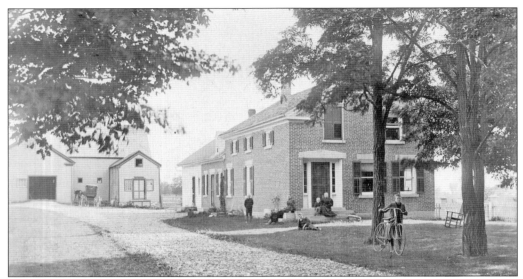

The sturdy brick house of Peter Fleury in Isle La Motte, Vermont, reflects Fleury's wealth and influence in the community. The people shown here may be Peter's son Edgar's family in the 1890s. It may be Edgar's wife, Cora, his five sons, and their nanny. (Courtesy Isle La Motte Historical Society.)

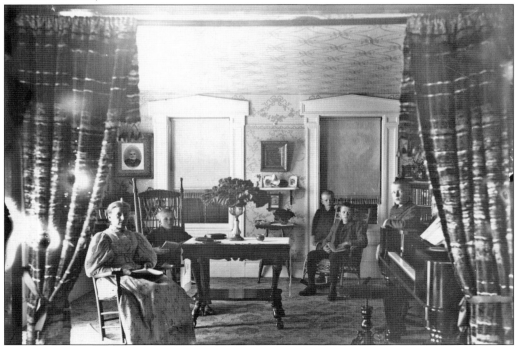

The interior of the Fleury house also reflects the family's affluence and would not have been typical of most French Canadians. The fine wallpaper, furnishings, and piano were outside the reach of day laborers, mill workers, and farmers. Peter Fleury's portrait is visible on the wall behind the woman in the rocking chair, who may be Cora, posing with four of her sons. (Courtesy Isle La Motte Historical Society.)

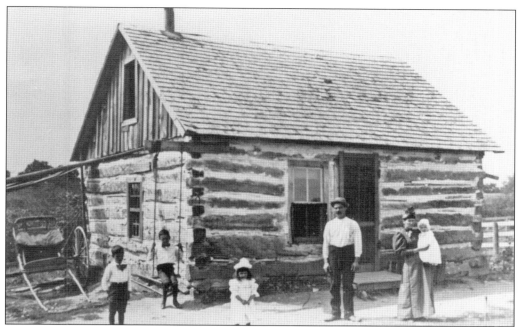

Pehan (Piene) Pearo (Perreault) Jr. and family stand in front of their log house in Isle La Motte. The photograph was taken by Wyman C. Holcomb around 1897. Pearo was a shoemaker who was born in Canada and had 19 children by two wives while living in Isle La Motte. This home is more typical of the French Canadian lifestyle in the United States. (Courtesy Isle La Motte Historical Society.)

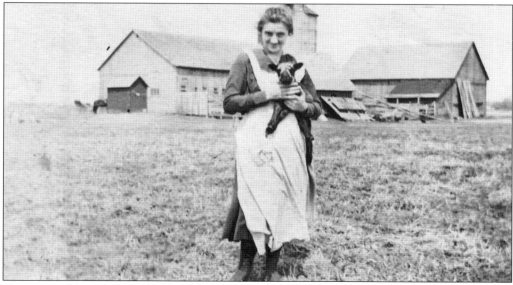

Genevieve Gload Ashline holds a black lamb in front of the Ashline farm on Rapids Road in Champlain, New York. The Ashline farm was established in the early 19th century by descendants of the first settler in the town of Champlain, Prisque Ashline (Asselin). Prisque was a soldier in Moses Hazen's Canadian regiment during the Revolutionary War and was granted land in northern New York for his service. (Courtesy Gloria Ashline.)

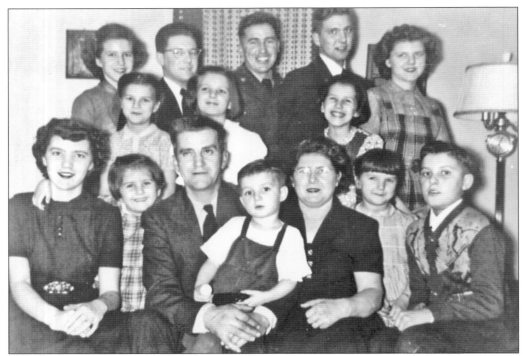

The Ménards of Mooers Forks, New York, are a typical large French Canadian family. Three of Bernard and Adele Arcouette Ménard's 13 children became priests and one a religious sister. (Courtesy Sister Elizabeth Ménard.)

This is the Antonio and Rita Pomerleau family of eight children. The Pomerleaus have been a fixture of the business community in Burlington for decades. From left to right are (first row) Ernie (and dog Princess), Dennis, and Grace (and dog Ludwig); (second row) Ann Marie, Patricia, Ellen, Antonio, Alice, Rita, Susan, Elizabeth, and Rosemary. (Courtesy Ernie Pomerleau.)

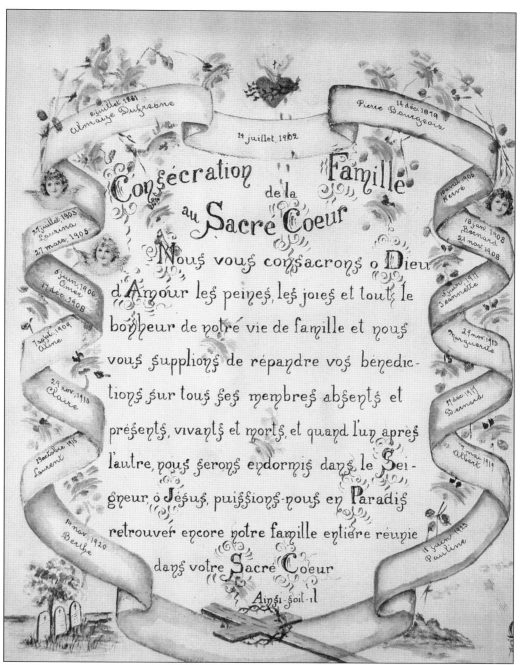

This document pledges the Bourgeois family's devotion to the Sacred Heart of Jesus. Catholics in France were known for their devotion to the *Sacré Coeur* of Jesus and his commitment to humanity. Pierre and Almaize Bourgeois of Waterford, New York, had 13 children. Three died young, and their deaths are commemorated by angels hovering near their names and tombstones at the bottom. (Courtesy Waterford Historical Museum and Cultural Center.)

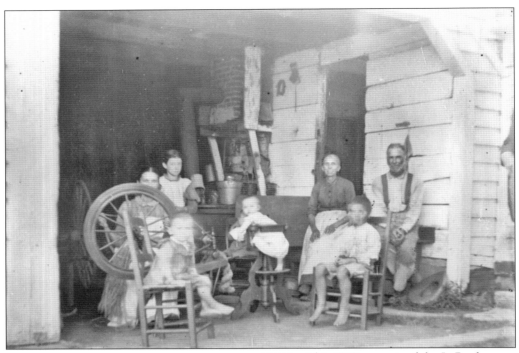

This 1898 portrait of the LaRoche family (sometimes Anglicized to Stone) of Champlain, New York, at their farmhouse proudly displays a spinning wheel, high chair, and several chairs. It was common for people to bring out their most prized possessions for photographs, as photographs were still rare occurrences in rural areas and families wanted to put their best foot forward. (Courtesy Special Collections, Feinberg Library, SUNY College at Plattsburgh.)

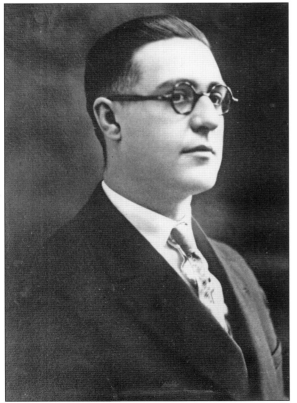

Frédéric Blaise represented Vermont in the boys' division of the semifinals of the Second National Radio Audition in 1929. Blaise was also the director of the St. Francis Xavier Choir in Winooski. (Courtesy Joseph Perron.)

Lawrence Villemaire, Aurelieu Thibault, Paul Picher, and Romeo Villemaire, singers in the Union Saint-Jean-Baptiste, sang as a group during intermissions of shows at Corporation Hall in Winooski between 1931 and 1940. (Courtesy Winooski Historical Society.)

Smiley Willette (Ouellette) and the Sunset Ramblers were a popular band in northern New York, Vermont, Québec, and Ontario in the 1950s and 1960s. Willette and his wife, Alfreda Phaneuf, and their band played on local radio stations and hosted a live television show, *Saturday Night Jamboree*, in New York and another show in Sherbrooke, Québec. The three albums they recorded were produced in Montréal. (Courtesy Randy Willette.)

Dédié à
M. Henri Ledoux,
Président de la Société Saint-Jean-Baptiste d'Amérique.

Chant de Ralliement
des
Franco-Americains

→ PAROLES DE ←
F. G. Deshaies
→ MUSIQUE DE ←
J. A. Contant
Prix, 35 cents.

F. G. Deshaies,
76 Whitney St.
NASHUA, N. H.

The "Rally Song" of Franco-Americans was issued in 1923 and dedicated to the president of the Union Saint-Jean-Baptiste d'Amérique. The song implores Franco-Americans to preserve their memories as brave Canadians and descendants of Old France. Music was a great passion for many French Canadians and it could be used to soothe one's soul in a time of need. Songs were crafted in lumber camps, as social protest, and upon starting a new life in the United States. One song written about departure for the United States included the lines, "Nous poursuivrons notre route, Dieu nous protègera d'accident. Je pars pour l'Amérique, Pour y gagner de l'argent, Si le bon Dieu m'y conserve, De peine et d'accident. Si Dieu vient à mon aide, J'espère que dans deux ans, Au retour du voyage, Y voir mes bons parents." (We will continue on our way, God will protect us from harm. I am leaving for America to earn my living there, If the good Lord keeps me from harm or trouble. If God comes to my aid, I hope that in two years, Upon my return from the trip, To see my dear parents there). (Courtesy Joseph Perron.)

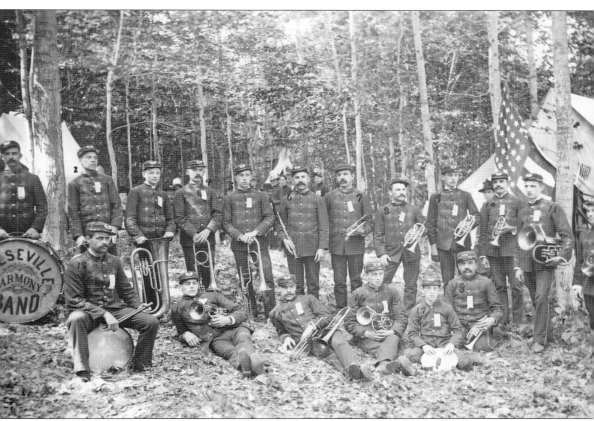

The Harmony Band from Keeseville, New York, was made up of mostly French members. The band was active from the late 1800s through the 1950s and played in New York and Vermont at public events including Franco-American gatherings. This photograph was taken at Willsboro Point in 1890 during a Grand Army of the Republic celebration. From left to right are (first row) Fred Castin, Napoleon Circé, Joe Rabideau, Louis Boulley, Eugene LaBoisseur, and Charles Bero; (second row) Joe Rondeau, Albert LaBoisseur, Arthur Boulley, William Tromblee, Fred Richards, Nelson Bero, Ed Bero, Charles Frechette, Alphous Burton, Fred Bero, Ed La Boisseur, and Crawford Frechette. (Courtesy Anderson Falls Historical Society.)

Members of the Canado-American Club of Rutland, Vermont, are in costume for a performance in 1910. From left to right are (first row) Ernestine Ducharme, Relda Bachand, Margaret Laventure, Georgiana Chevalier, Pauline Courcelle, and Genette Robillard; (second row) Leon Robillard and Enos Courcelle; (third row) Blanche Gosselin, Blanche A. Durivage, Anna Galarneau, Josephine Latrimore, Cecile Branchaud, Jennie Martin, Nellie Durivage, Julia Provost, Emma Marceau, and Nellie Galarneau. Standing at left is Prof. Andrew Ducharme. (Courtesy Rutland Historical Society.)

Another theater club, the Dramatic Circle of Saint Cécile, was part of the Winooski Union Saint-Jean-Baptiste. This photograph, taken at Hector Huard Studio on the corner of Main and West Allen Streets, includes Florence Mongeon, Jeanne Picher, Agnes Hébert, Blanche Lord, Laurent Villemaire, Maurice Paquette, Henri "Mike" Villemaire, and Edouard Matte. (Courtesy Winooski Historical Society.)

Pish-nut is a wooden tabletop game of French Canadian origins, like the Indian game carrom or crokinole with mechanics that lie somewhere between pocket billiards and air hockey. Although the board in this image was commercially made, boards were often handmade, and the game was common in the farming villages south of Sherbrooke, Québec. (Courtesy Céline Racine Paquette.)

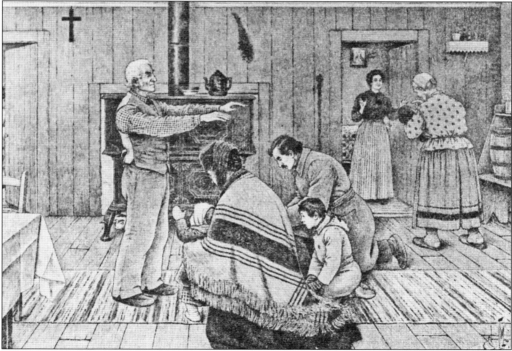

Born in 1875, Edmund Massicotte was a Canadian artist who captured the traditions of French Canadians in many of his paintings and prints. In this print, titled *La Bénédiction du Jour de l'An*, the father blesses the family on New Year's Day. It was a custom repeated in many Franco-American homes throughout New York and Vermont. (Courtesy Samuel de Champlain History Center.)

This 1512 woodcut illustrates the myth of the *loup-garou*, or werewolf, in European folklore. The French were captivated by the idea of a man who could shape-shift into a werewolf. The loup-garou was thought to roam the countryside at night in search of victims. French Canadians brought this story to northern New York and Vermont when they relayed it to their children as a morality tale. Fear of the loup-garou was an effective foil to bad behavior of all sorts. The story was so widely told among French Canadians that the Canadian government issued a stamp depicting a loup-garou in 1990. (Courtesy Kimberly Lamay Licursi.)

Daniel "Baptiste" Trombley smiles into the camera in this undated photograph. Baptiste (or Batiste) was his pen name as the author of several books of poetry written in folksy French Canadian dialect. He was known as the "Poet of Isle La Motte," and his work remained in print in pamphlets and newspapers for over two decades during the early part of the 20th century. He was a descendant of Canadian Laurent Bruno Tremblé, who fought on the American side during the Revolutionary War. The name evolved over the years to Trombley. (Courtesy Isle La Motte Historical Society.)

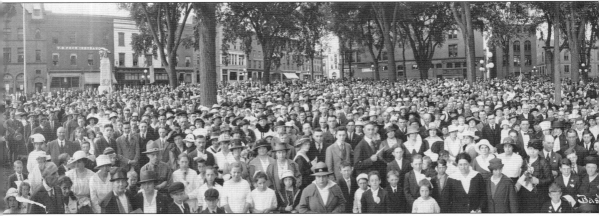

In this photograph, a crowd of thousands gathers to celebrate Bastille Day in City Hall Park in 1918. The French celebrate Bastille Day in honor of the storming of the Bastille prison in Paris on July 14, 1789, as part of the French Revolution against the monarchy. A message was sent to the people of France noting that "Burlington . . . overlooking the lake discovered by a hero of France, a Vermont city once the host of LaFayette, greets France and sends a message of

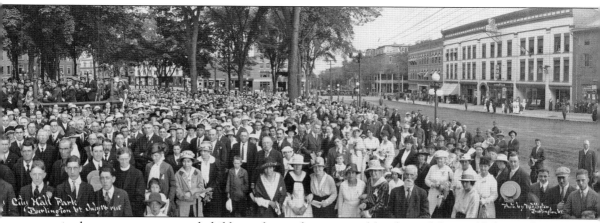

gratitude to men, women and children who as champions of freedom of the world during four years of heroic sacrifice, have proved themselves altogether worthy of the glorious memories of Champlain and Lafayette." The French had been fighting World War I against the Germans since 1914, and the Americans had joined in the battle in April 1917. (Courtesy University of Vermont Special Collections.)

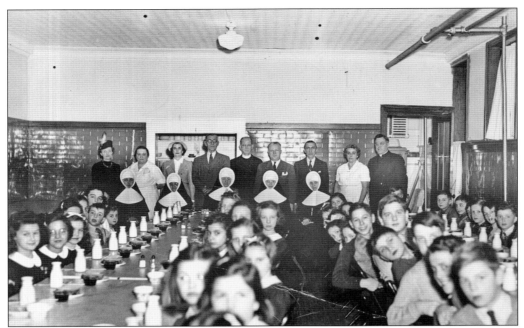

The caption of this photograph of the cafeteria at St. Alphonsus School in Glens Falls, New York, references the priest's famous yellow pea soup. Pea soup, sugar pie, and tourtière, particularly at Christmas, Easter, and New Year, are traditional French Canadian staples. (Courtesy Chapman Museum.)

French-language newspapers were started in several locations south of the Canadian border to cater to the growing populations of French Canadians. The first French newspaper in Vermont was *La Patriote Canadien*, founded in 1837 in Burlington, but it only lasted for two months. *Le Protecteur Canadien* began publication in St. Albans in 1868 with the motto "Love God and go thy way." (Courtesy Assumption College.)

Immigrants in Glens Falls published *Le Drapeau National* for one year in 1880. *Le National* was published in Plattsburgh beginning in 1883 and was in print for many years. (Both, courtesy Assumption College.)

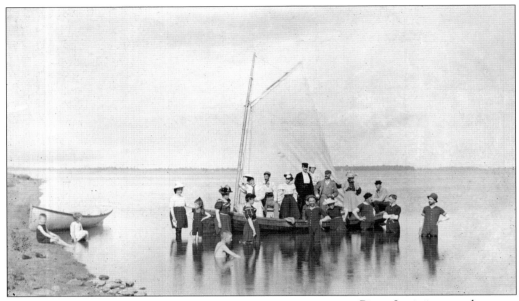

Noyés, les Français!

MONSIEUR LE CURÉ.—And so, Mary Ann, you are going to marry Joachim Bédard. That's a good girl. If all our good Irish girls were to do the same, there would not be a Frenchman to be seen in New England in twenty-five years. For you know, Mary Ann, that when the mother is Irish, the children are sure to be Irish too.

Pierre Larivière stands at the mouth of the Great Chazy River with friends and family in this undated photograph. He was a well-respected product designer for Sheridan Iron Works in Champlain, New York, and held several patents in the field of bookbinding machinery. He traveled both the United States and internationally for Sheridan in the early 20th century. (Courtesy Samuel de Champlain History Center.)

This cartoon, titled *Noyés, les Français!* (Drown out the French!) demonstrates resentment of the French. The drawing depicts an Irish priest congratulating his Irish maid on her marriage to a Frenchman. The priest is happy because this will dilute French influence. He notes, "When the mother is Irish, the children are sure to be Irish too." (Courtesy Samuel de Champlain History Center.)

Notre Dame de l'Assumption Church, in Redford, New York, has a long history of celebrating the laying of its cornerstone on August 15, 1856. The date is also known as the "Fifteenth of Redford," where the church is located. The picnic was replete with French chatter and food reflecting the ethnicity of those served by the church. It is still celebrated today. (Courtesy Sylvia Newman.)

In 1909, the Garde d'Honneur, or Honor Guard, stands in front of the Free Library in Rutland, Vermont. This building is now the Rutland Post Office. The Garde d'Honneur was a division of the Union Saint-Jean-Baptiste and could be made up of female or male members depending on the chapter. According to a newspaper account, the Garde d'Honneur in Plattsburgh, New York, was selected to perform guard duty for the French ambassador to the United States, Paul Chandel, in 1929. The Gardes d'Honneur also participated in ceremonial events. (Courtesy Joseph Perron.)

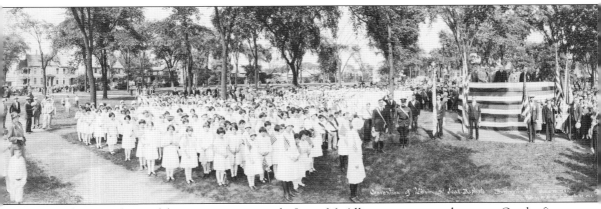

A close-up of part of this panoramic image by Louis McAllister appears on the cover. On the first day of the convention of the Union Saint-Jean-Baptiste in June 1928, a crowd of approximately 1,200 in Battery Park listened as Vermont congressman E.S. Brigham spoke. The *Burlington Free Press* noted that he "lauded the great assemblage for its spirit in keeping alive by such a magnificent demonstration, its ancestral traditions. Why the members of the union have every reason to take pride in the material part their forbears played in the establishment of this country, with its liberty

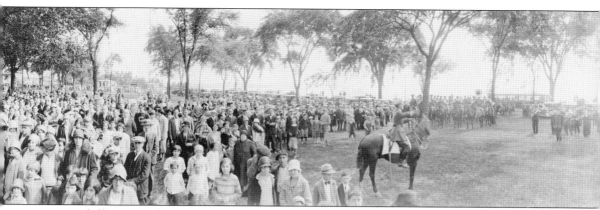

to men of all races and creeds was explained by the congressman speaking from the decorated stand in the park. He told of early explorations by dauntless men of France who will ever have a place in history. Facing Lake Champlain, which was hardly ever more lovely at that hour of the afternoon, he spoke of Samuel de Champlain's character and great contribution to the nation." (Courtesy University of Vermont Special Collections.)

DISCOVER THOUSANDS OF LOCAL HISTORY BOOKS FEATURING MILLIONS OF VINTAGE IMAGES

Arcadia Publishing, the leading local history publisher in the United States, is committed to making history accessible and meaningful through publishing books that celebrate and preserve the heritage of America's people and places.

Find more books like this at
www.arcadiapublishing.com

Search for your hometown history, your old stomping grounds, and even your favorite sports team.